Contemporary Casta Portraiture: *Nuestra "Calidad"*

*This amoxtli or book is dedicated to my mother Amalia Garcia,*
*una manita de Nuevo Mexico, who breathed in her children a passion*
*for life. With this endeavor I honor her determination.*

Delilah Montoya

# Contemporary Casta Portraiture: *Nuestra "Calidad"*

Delilah Montoya

with essays by

Surpik Angelini

Mia Lopez

Holly Barnet Sanchez

Publication of *Contemporary Casta Portraiture: Nuestra "Calidad"* is funded by grants from the University of Houston Center for Mexican American Studies and the City of Houston through the Houston Arts Alliance. We are grateful for their support.

*Recovering the past, creating the future*
Arte Público Press
University of Houston
4902 Gulf Fwy, Bldg 19, Rm 100
Houston, TX 77204-2004
www.artepublicopress.com

Cover Image
Delilah Montoya, *Contemporary Casta Portraiture: Nuestra "Calidad"*, Casta 14, 2017
Infused Dyes on Aluminum

Book Design
Beckham Dossett

Montoya, Delilah.
    Contemporary Casta Portraiture: Nuestra "Calidad"/photographs by Delilah Montoya
    p. cm.
    ISBN: 978-1-55885-845-9

# Contents

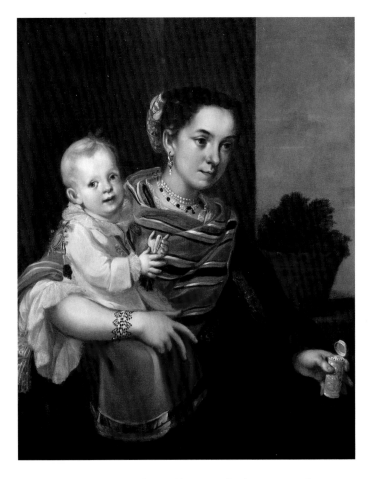

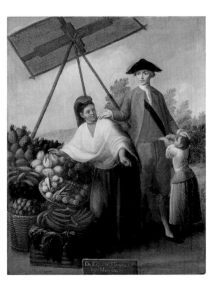

Francisco Clapper, from *Spaniard and Indian born Mestiza* (*De Español e India nace Mestiza*), circa 1775, Oil on canvas, 20 x 15½ inches. Gift of the Collection of Frederick and Jan Mayer, (2011.428.1) Denver Art Museum Collection. Photography courtesy of Denver Art Museum

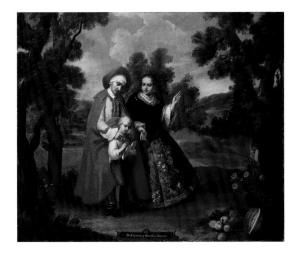

Mexico, *Morisca Woman and Albino Girl* (*Morisca y albina*) circa 1750, Oil on canvas, 36 × 28 inches. Purchased with funds provided by the Bernard and Edith Lewin Collection of Mexican Art Deaccession Fund (M.2009.62) www.lacma.org

Juan Patricio Morlete Ruiz, from *Spaniard and Morsica, Albino* (De *español y morsica, albino*), circa 1760, Oil on canvas, 39⁷⁄₁₆ × 47⁷⁄₁₆ inches. Gift of the 2011 Collectors Committee (M.2011.20.1) www.lacma.org

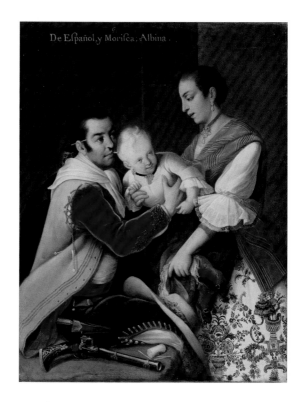

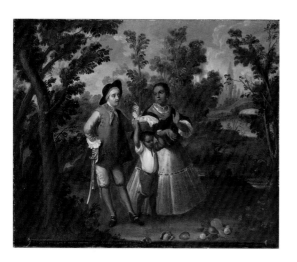

Juan Patricio Morlete Ruiz, from *Spaniard and Return Backwards, Hold Yourself Suspended in Mid Air* (De *español y torna atrás, tente en el aire*), circa 1760, Oil on canvas, 39½ × 47 ½ inches. Gift of the 2011 LACMA Collectors Committee (M.2011.20.3) www.lacma.org

Miguel Cabrera, from *Spaniard and Morisca, Albino Girl* (De *español y morisca, albina*), circa 1763, Oil on canvas, 51⅝ × 41⅜ inches. Purchased with funds provided by Kelvin Davis in honor of the museum's 50th anniversary and partial gift of Christina Jones Janssen in honor of the Gregory and Harriet Jones Family (M.2014.223) www.lacma.org

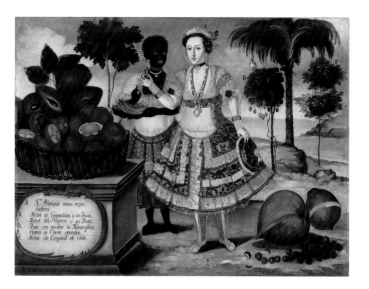

Vicente Albán, *Noble Woman with Her Black Slave* (*Señora principal con su negra esclava*), circa 1783, Oil on canvas 32 × 41¾ inches. Purchased with funds provided by the Bernard and Edith Lewin Collection of Mexican Art Deaccession Fund (M.2014.89.1) www.lacma.org

Surpik Angelini

# The (E)Quality of *Nuestra "Calidad"*

While globalism made its way in various cultural circuits during the eighties, an acute interest in embedded local knowledge helped loosen the Eurocentric grip on modern art. This evolving condition spawned what we know as post-colonial art. Far from being rooted in Western "humanism"—entrenched in a colonial political economy—post-colonial art attempts to rewrite history exploring local micro politics, releasing the voices of marginal a-historical "Others." Thus, in tandem with Michel Foucault's critical thought, it tends to disrupt Modernism's metanarratives: its collusion of power and knowledge, its autonomous claim to universality and its belief in progress driven by institutional racism.

With the inception of the Havana Biennial of 1984, cultural critics Gerardo Mosquera and Nelson Herrera Isla gathered artists and intellectuals from the Americas, Africa and Asia to stage major exhibitions and debates introducing a Third World perspective on contemporary art. The same year, art critic Thomas McEvilley publicly denounced colonial curatorial practices, underscoring the blockbuster exhibition *'Primitivism' in 20th Century Art: Affinities of the Tribal and the Modern* at The Museum of Modern Art in New York. He exposed how the curators minimized the value of non-Western artifacts, disregarding their cultural, social and political context, while highlighting the "originality and uniqueness" of Western modern masters. McEvilley's radical anti-colonial stance foreshadowed Jean Hubert Martin's seminal 1989 exhibition in Paris, *Les Magiciens de la Terre*, where a wide range of indigenous and contemporary artistic expressions of modernity from Western and non-Western worlds came together, evidencing how colonization impacted individual and collective memory. In the same vein, but emphasizing the problem of

exclusion, in 1990, curators from the New Museum, the Studio Museum in Harlem, and the Museum of Contemporary Hispanic Art organized *The Decade Show: Frameworks of Identity in the 1980s*, featuring such Hispanic artists as Cecilia Vicuña, Amalia Mesa-Bains, Ana Mendieta, Andrés Serrano, Luis Jiménez and Alfredo Jaar. On the heels of *The Decade Show*, David Ross curated the 1993 Biennial at the Whitney Museum of American Art, where a generation of previously marginalized artists, such as Renee Greene, Lorna Simpson, Glenn Ligon and Pepón Osorio, engaged in "the construction of identity" from a personal, historical and socio-political perspective, challenging the institution's white primacy.

This all too brief summary of trailblazing events leading to epistemological changes induced by post-colonial art would not be complete nor relevant when contextualizing the work of Delilah Montoya, without compounding the effects of what Hal Foster called "the ethnographic turn" in the eighties, which ignited myriad social experiments in the arts. A revised ethnography, questioning the authority and ethics of representation resulted from a radical critique of the current thought process in the social sciences through such publications as *Writing Culture: The Poetics and Politics of Ethnography*, edited by James Clifford and George E. Marcus in 1986 and *The Predicament of Culture: Twentieth-Century Ethnography, Literature, and Art*, James Clifford in 1988. Thus, what is now termed as "art as the production of knowledge"—so pertinent to Montoya's work—emerged as ethnographic fieldwork and took part in the creator's process. In this respect, we should mention Okwui Enwezor's surveys of contemporary ethnographic practices in art, seen through three exemplary exhibitions he curated: the 2002 *Documenta XI* in Kassel, *Intense Proximity* for

the 2012 Paris Triennale in the Palais de Tokyo (former legendary Musée de l'Homme ) and his most recent *All the World's Futures* for the 56th Venice Biennale in 2015. Enwezor states in the catalog for *Intense Proximity*: "Twentieth century ethnography's great legacy, and its impact on the world of forms and visual production, is thus not simply in the prodigious research output it manifested nor in its voracious appetite for radical alterity. Rather it was in its excavation and aesthetic mining of the moment of ethnographic encounter, a strange field of sensorial mythopoetics in which otherness was registered and transformed in the visual field by the speculative camera."[1]

Delilah Montoya's investigation of the ethnic roots of families of colonial heritage presently living in New Mexico and Texas belongs to this genre of ethnographic art, as she mimics and critically examines the complex genealogy of seventeenth- and eighteenth-century Mexican casta paintings. Disseminated in Europe and the New World, the paintings render up to sixty types of miscegenation involving the Hispanic White, Amerindian and Black ethnicities in colonial Mexico. While the rigid casta system secured the white man's New World supremacy, in hindsight, racial purity in Spain could be questioned, given the Moorish occupation from 711 AD up to the discovery of America in 1492, when Muslims were forcibly converted to Christianity. Moreover, if the casta system resulted from old World "humanism," it ironically "cast" profound doubts about the humanity of non-white subjects.

At this juncture, we cannot proceed without taking into account how the 1960–70's Chicano Movement, border crossing and hybridization influenced Montoya's artistic development. In their studies of migrant cultures, Nestor García Canclini, and Homi K. Bhabha point out alternative cartographies that uproot accepted Western canons. One such alternative emerged as the Chicano Movement forged cultural inroads into mainstream art institutions. As early as 1987, *Hispanic Art in the United States* at the Museum of Fine Arts Houston featured a number of up-and-coming Chicano artists. Several landmark shows generated in Los Angeles followed suit: *Chicano Art: Resistance and Affirmation* (CARA), a major traveling exhibition from 1990 to 1993 initiated at the Wight Gallery at UCLA, gathered 180 Chicano artists. It explored their pre-Columbian history as well as their contemporary

manifestations as seen through four themes: Feminist Visions, Reclaiming the Past, Regional Expressions and Redefining American Art. Spearheaded by Shifra Goldman and Cecelia Klein since 1983, and supported by Tomás Ybarra-Frausto at the Rockefeller Foundation, María de Herrera, Holly Barnet-Sánchez and Marcos Sánchez-Tranquilino collaborated to bring Chicano art out of its category of subculture to be recognized as a relevant, influential genre that integrated art and politics. In 2001, the Los Angeles County Museum of Art (LACMA) presented Victor Zamudio-Taylor and Virginia Fields's *The Road to Aztlán: Art from a Mythic Homeland*, honoring the symbolic re-naming of the American Southwest. A significant biennial event for border art since the mid-nineties is *InSITE*, which promotes bi-national collaborations and commissioned art installations in the border zone between San Diego and Tijuana. In time, as multiculturalism waned, so did radical claims of ethnic identity. Thus, the 2008 *Phantom Sightings: Art after the Chicano Movement* became one of the first "post-ethnic" exhibitions coinciding with the first "post-racial" candidacy of Barack Obama.

These cultural events share common territory with Delilah Montoya's artistic pursuits, as she participated in both CARA and *Phantom Sightings*, as well as many other historical markers for Chicana feminist art. In fact, her latest post-colonial project, *Contemporary Casta Portraiture: Nuestra "Calidad,"* embodies both a retrospective and futuristic vision of ethnicity. In her own words, her work entails "the investigation of the cultural and biological forms of 'hybridity.' Looking at this concept as a signifier of colonialism, the portraits echo the aesthetic and cultural markers formulated by the casta paintings of the seventeenth and eighteenth centuries in present-day familial settings of New World multicultural communities. The idea is to witness the resonance of colonialism as a substructure of our contemporary society."[2]

What sets Montoya's art apart from other ethnographic, as well as politically infused works, is her proximity and familiarity with her subjects. The unconscious effect of the carefully constructed social hierarchy supporting white supremacy in the colonial casta system still percolates in the artist's imaginary. As Foucault would see it, though casta's consciously manipulated social norms are no longer believed to be determined "scientifically," the artist

is painfully aware that they become an unconscious episteme affecting collective self-image and social behavior. Thus, Foucault's archeology of knowledge and its entanglement with power is what Montoya seems to unpack by photographing the families in their environment, researching their ethnic origins through DNA studies and tracing their geographic migration routes in world maps that exceed post-colonial and modern territorial boundaries. The presence of each family is compelling enough, but as we learn the secrets of their ethnic origins, it becomes clear to us how deep their stories are. This wordless, "thick description," as anthropologist Clifford Geertz would call it, is charged with deconstructive energy. Suddenly, our assumptions recede, and a new social reality asserts itself, as we realize that we are all the result of a complex assemblage of factors. Thus, we can begin to dismantle the episteme ruling the insidious casta stereotypes.

Other factors adding ethnographic density to Montoya's portraits are the material objects, architectural settings, furnishings and even pets that the artist captures in each family group. In his study of the *System of Objects*, Baudrillard observed that human beings and objects are bound together in a collusion in which objects take on a certain emotional value, or "presence," adding that as necessary as dreams, people tend to collect objects that encapsulate personal histories and a desire to transcend time.

> What gives the house of our childhood such depth and resonance in
> memory is clearly this complex structure of interiority, and the objects, the
> furniture, and its arrangement within it serve for us as boundary markers of
> the symbolic configuration known as home.[3]

Interestingly, in Montoya's work, people and objects are portrayed with equal intensity, unveiling rich layers of affective data. Optically, her scenes are set within a great depth of field. While the protagonists, the mother and father in each family, are foregrounded, telling aspects of their life seem to peer accidentally from the background, even though they result from a montage of different instances. Within the consistency of Montoya's *mise-en-scènes*, each family is distinctly portrayed with no attempt to homogenize its lifestyle or

character. Nothing looks posed, yet each layer of information speaks of difference, meticulously telling a condensed story. The artist is careful in letting the subjects speak for themselves, and an underlying complicity, though subtle, is essential in asserting the veracity of the document she produces. As Baudrillard would see it, the consistency in Montoya's photographs "is not the natural consistency of a unified taste but the consistency of a cultural system of signs."[4] Personal and intimate on many levels, Montoya's work symbolically probes as deep as DNA's molecular dimension. If the nineties was known for its identity politics and multiculturalism, works such as *Contemporary Casta Portraiture* surpass nationalist, ethnic categories to suggest instead the making of a cosmic race. This is not only a timely message, as we witness the resurgence of racism and fundamentalism in our present world, but a provocative reflection of recent debates led by post-humanist philosophers engaged in the subject/object/nature/culture divide, and the new anti-racist thinking induced by the *bios/zoe* power of such things as DNA social discrimination.[5]

My own interest in Montoya's art lies in observing how her photographic installations involve the spectator in ways that are inaccessible to written ethnography, which is indeed one of the problems of representation that anthropology has been grappling with since the so-called "ethnographic turn." Therein lies art's poetic eloquence, when it evokes affect and meanings that words cannot convey, making the invisible visible, through what Walter Benjamin, in his reflections on photography, called "the optical unconscious," a realm Montoya masters both in form and content in *Contemporary Casta Portraiture: Nuestra "Calidad."*

1   Okwui Enwezor, ed., *Intense Proximity: An Anthology of the Near and Far.* (Paris: Palais de Tokyo, 2012), pp. 27–28.

2   Delilah Montoya, Artist Statement, 2017.

3   Jean Baudrillard, *The System of Objects* (New York: Verso Books, 1996), pp. 16–17.

4   Ibid, p. 40.

5   Rosi Braidotti, *Transpositions* (Malden, MA: Polity Press, 2006), p. 57 and p. 63.

Mia Lopez

# Restaging Casta and Demystifying Genetics in Delilah Montoya's *Nuestra "Calidad"*

In a 2004 opinion piece for the *Los Angeles Times*, Gregory Rodríguez problematized the exhibition *Inventing Race: Casta Painting and Eighteenth-Century Mexico* at the Los Angeles County Museum of Art. The exhibition featured dozens of paintings of colonial Mexican families, organized and labeled according to politically charged notions of race and class. In his column about the exhibit, Rodríguez stated that although casta paintings were no longer mistaken by scholars for literal depictions of racial reality, they still influenced Mexicans' self image and might provide insight into contemporary race ideology. In his article, "An Unsettling Racial Score Card," Rodríguez stated,

Today the relative absence of dark-skinned actors on Mexican television is a legacy of [the casta] tradition. Some Latin American-born advertising executives have imported this prejudice to the United States. Their advertisements routinely feature light-skinned models in campaigns designed to target a Latino population that is distinctly heterogeneous. Essential to understanding Mexican history, the mestizo consciousness [posited by casta paintings] is increasingly influencing visions of the American future.

Following the Mexican Revolution, Mexican politicians and scholars adopted a new national identity centered on mixed-race identity, or *mestizaje*. The notion of *La Raza Cósmica* or *La Raza* emerged in part as a strategy to unify a population that had been structured around racial difference. By embracing a collective identity of multiplicity (albeit still preferential to Spanish origins), Mexican leaders hoped to unify the populace and foster national pride. Nearly a century later the impact of this movement still resonates, as the majority of

Mexicans and Central Americans identify as mestizo. By contrast, a 2015 Pew Research survey found that only 6.9% of Americans identified as multiracial.[1] This stark difference is indicative of a widely held black-and-white perspective on race in the United States, complicated by institutionalized racism and pervasive colonialist attitudes. It is this site of contestation, myth and erased history where artist Delilah Montoya locates the series *Contemporary Casta Portraiture: Nuestra "Calidad."* Her photographed portraits and accompanying DNA analysis provide insights for both sitter and viewer on the instability of identity and the means through which we are inclined to construct our own histories.

*Nuestra "Calidad"* was born out of Montoya's research and interest in the racial categorizing that originated in New Spain but continues to manifest itself in modern society. Like the paintings on which they are based, the photographs adhere to a common structure: a family is asked to sit for a formal portrait in the setting of their choice, the photographer digitally edits and composites several shots to compose an image, and the final image is accompanied by racial identifying information. However, unlike the descriptive titles and labels used in colonial casta portraits, Montoya introduces racial heritage data by juxtaposing the photos with DNA genetic analysis. States the artist,

> The idea is to comprehend colonialism as the substructure of our contemporary social footprint. In using present-day tools (DNA testing and digital media) as part of the construction of the family portraits, the photographic studies will ascertain the family's genetic migration and social affiliations in the same way that the semiotics of the casta painting reveals the colonial social structure.[2]

Montoya solicited families to participate via a website and in person. Although she ultimately exercised artistic license over the final works, she emphasized maintaining the agency of her subjects and allowing them to stage their own representation. This is a marked departure from the original casta paintings, whose intentions were writ by the artist long before the subjects were even selected. The setting of each photo—living room, restaurant,

kitchen, church, family business—underscores the sociological function of the series, while imbuing the scene with intimacy and belying the artist's own disarming demeanor. Montoya's digital edits and composition skills are well concealed, as the photographs seem natural and unstaged.

Both Montoya and the original casta painters were driven by a desire to create works that unified science and art. Colonial artists in New Spain sought to elevate their status by employing scientific techniques and extolling their God-given talent to capture the essence of humanity. The concept of *disegno* or *dibujo* expanded on theories of intellectual enlightenment from God and was defined by Vincent Carducho (1576–1638) as "a method of understanding and revealing what is real and true in nature."[3] Carducho and other theorists also referenced scientific elements of symmetry, proportion, anatomy and perspective. Disegno was invoked to make a case for something being ontologically truthful,

> ... rendering visible the otherwise invisible nature of their subjects through science. A portrait is a matter of copying nature accurately, *ritrarre* in the Italian, while a casta painting is a matter of idealized invention, correspond to the higher calling of *imitare* (Córdova and Farago 146).

Just as the artists in New Spain utilized scientific ideology to ground theories of caste hierarchy and miscegenation, Montoya incorporates DNA analysis to underscore the notion that racial identity is rooted in science. She has utilized tests sold by the National Geographic Society's Genographic Project, an anthropological genetic research project that analyzes historical patterns in DNA from people around the world. Participants, including Montoya's subjects, use testing kits at home to collect a sample of their DNA, which is then mailed to a lab for examination. The results of the test are then compared against nearly 750,000 DNA markers to provide percentages of distant ancestry from nine distinct regions spanning the entire globe and multiple migration patterns.[4] Participants receive access to their results via a personalized website, which provides visualizations of migration patterns and other ancestral data, as well as the opportunity to receive updates as the study

progresses. Montoya's subjects grant her access to their results, from which she takes a visualization of their DNA-based racial makeup with percentages representing the presence of the nine ancestral regions. For the artist, *Contemporary Casta Portraiture: Nuestra "Calidad"* is a natural evolution of portraiture in the 21st century. Asserts Montoya, "Given the current state of technology, a portrait should be more than a topographical likeness, it should point to the historical, social and economic status of the subject."[5]

Although Montoya's perspective on the function of portraits is expressed through contemporary media, it is important to consider it within the context of the historical casta paintings. In eighteenth-century New Spain, portraiture was exclusively for the upper class, and it was only through the incorporation of a sociopolitical and scientific utility that the lower classes began to be painted. Write James M. Córdova and Claire Farago,

> While the elite commissioned individuated representations of themselves in the form of portraits, the underclasses were represented by others, for others, in richly elaborated, beautifully crafted typologies that focused on the particular but not on individual identity (139).

Although Montoya's project similarly employs elements of modern science and research, her process and intentions have clear ethical and value distinctions from the colonial casta paintings. Perhaps most critical is the artist's desire to allow her subjects to present themselves as they want to be seen. This should not be misconstrued as permitting the portrait sitter to construct a parafiction, but is instead an acknowledgment of and respect for their individual agency. By contrast, even the most socially progressive colonial artists still partook in the creation of a system that delineated class status based on the amount of European (white) blood in a person's lineage.

In discussing her research, Montoya has expressed a fascination with the role of artists in colonial Mexico and their own relationships to caste and race. Just as they were complicit and participated in the creation and dissemination of class ideology, the artists themselves struggled with their place in society. Considering the sociopolitical status of the artist in the production of eighteenth-century casta paintings provides critical insight into the many subtexts and allusions contained within the paintings. Furthermore, although separated by centuries and immeasurable social progress, reflection on the colonial artists and their lives draws interesting parallels to Montoya's own position as an artist. As she attempted to work with a group of people who represented the diversity and range of mixture within the United States, she encountered certain limitations due to her own social standing. As a working artist Montoya found the top 1% of the population inaccessible and struggled to locate portrait sitters whose wealth embodied the most elite of the casta classes. Similarly, she realized that the struggles of families affected by mass incarceration were most akin to those of the oppressed African and indigenous peoples that casta paintings depicted. Yet she found herself unable to connect with a family that had a loved one in jail, due both to her own class and social interactions as well as her desire to avoid exploitation or profiteering. This process of selecting families and exploring social boundaries makes visible the class hierarchies in the United States today and further illustrates how casta paintings continue to resonate.

As explained in great detail by Córdova and Farago, in New Spain casta paintings emerged at a time when art academies were beginning to form in Mexico City, with the intentions of elevating painting to the status of science and excluding indigenous, racially mixed or untrained artisans (129).

> From the perspective of leading New Spanish painters, moralizing genre scenes established their parity with European painters, who already enjoyed an elevated status as practitioners of a liberal art grounded in scientific principles and taught in prestigious academies (150).

Painters in colonial New Spain distinguished themselves from their continental counterparts by utilizing a more expressive, animated gesture. The presence of the painter's hand, or *maniera*, asserted the artist's individuality while blurring the distinction between science and art (Córdova and Farago 145). Although this was part of a larger attempt at upward social mobility, it nevertheless underscored the artistic impulse towards

embellishment or fabrication. Scholars concur that despite efforts by artists to utilize casta painting to make a statement about the relationship between Spain and the colonies, these attempts were futile at best.

> ... the deluxe ethnographic subjects were still objectifying, exoticizing representations that situated New Spanish society and its most talented artists in a subordinate position in a transcultural, transatlantic social and artistic hierarchy. Ethnographic illustrations, even lusciously painted ones imaginatively composed and filled with what were appreciated as both fascinating exotica and informative scientific information, were destined for scientific collections and curiosity cabinets, not collection of painting and sculpture (Córdova and Farago 150).

Although casta paintings would ultimately be historicized as artwork, in their contemporary time they ironically lacked the *calidad* necessary to be viewed as fine art. While the term literally translates to quality, its origins are as a racializing category that fused race, class, honor and skill in evaluation of painting (Córdova and Farago 139). That Montoya invokes calidad in the title of the series is demonstrative of the project's self-awareness and her complex sociological investigation of familial and personal racial identities.

Though Montoya worked with a diverse group of people from different communities and with varying socioeconomic status, some commonalities emerge in the portraits. Many of the families chose to be photographed during mealtimes, gathering around a table or cooking together. Rarely are only nuclear parent and children groups pictured. Instead, many of the images capture grandparents and extended family as well, and in some instances close friends and household pets. However, these similarities become visible only when viewing multiple photographs at a time. Taken individually, the casta each tell the distinct story of one family. Yet when placed within the context of the larger project and viewed as a group, the casta become archetypes, illustrating the many permutations of the American family in the 21st century.

Montoya is careful to both conceal the identities of her subjects and to remain neutral regarding their beliefs and lifestyles. Though her practice is not quite ethnographic, she allows the people in her photographs to speak for themselves, albeit within the parameters she sets. *Casta 14* presents an image so poised and picturesque that it feels like a scene from a movie. The photo depicts a family gathered at a farm to table restaurant that they own. This image might be compared to an upper class mestizo casta painting, replete with trappings of success and "good taste." The restaurant owner's mother chose the location and invited several generations of extended family to join her for the lunchtime portrait session. She had a clear vision for how she wanted her family to be portrayed, and very much staged the scene as such. The adobe walls in the background provide a counterpoint for a family meal that is markedly contemporary. People use cell phones to share images and tell stories across the table, amidst partially clear dishes and floral arrangements. It is clear to the viewer that the image represents an action shot—lunch is still occurring and people are in motion. Here, Montoya again asserts her creative authority perhaps pushing back on any attempts by the subjects to pose for the camera. Instead the composite photograph dilutes any sense of elitism that the family may have intentionally or otherwise projected. Despite touting centuries of history and a proud Spanish heritage, they are ultimately an ordinary family simply enjoying a meal together.

The allusions to mestizaje in *Casta 14* are far from superficial. As Montoya became familiar with different families due to her work on the project, she became aware of their individual and collective impressions of family history. Notably, most if not all of the families had fairly specific preconceived notions about their racial lineage. These ideas of heritage and history are not dissimilar to origin myths, as they are passed down across generations and often form the basis for identity formation. A concept of ancestry and family lineage is often a source of pride, and for some families a means of distinguishing themselves from others, not unlike the original casta subjects. The family portrayed in *Casta 14* has ties to the original Spanish land grants in New Mexico, which they were aware of before the project. The DNA analysis confirmed indigenous maternal lineage as well as Mediterranean ancestry—the exact combination that was originally considered Mestizo.

Unlike the colonial casta painters, who were commissioned by Spanish

nobility and thus carefully adhered to hierarchical stereotypes, Montoya is not interested in perpetuating dominant and prejudiced world views. Rather, the *Nuestra "Calidad"* project affords her the artistic license to confront and dismantle preconceptions about race and ethnicity so as to illustrate a more complex concept of identity in the United States in 2016. As mentioned previously in this essay and by the artist, she ultimately sought to use the casta structure to create an allegory for contemporary race and class issues. Thus, given the current political climate and rhetoric, the inclusion of a Muslim family was clearly essential. In *Casta 15* a Black Muslim family gathers casually in the living room. Montoya discussed their history and the misconceptions strangers have about them. This family in particular traces its religious heritage to the civil rights movement. They are pictured in a fairly mundane, quotidian moment, relaxing in their living room. Four children are playing, occupied with video games, a laptop and a toy squirt gun. Their father engages the smallest child with the computer, while the mother is sitting down, enjoying her family. Again the photographer's role feels nearly ethnographic, as no one seems to acknowledge her presence. The family is natural and relaxed, their living room a comfortable balance of neatness and lived-in.

Participation in the project was largely influenced by the father of the family, as he is an artist and also has questions about his familial origins. Specifically, although he was aware that his family had came to the Southern United States from West Africa via the slave trade, he had heard about a white grandmother somewhere in his lineage. DNA results confirmed a small amount of Northern European lineage, confirming the family legend.

The first photograph in the series, *Casta 1*, circles back to the genre's foundation in religious art as it depicts a family in a chapel. During the colonial era, paintings primarily fell into one of two categories: Catholic imagery or portraits of nobility. Artists were trained to do both simultaneously, mastering their style while learning the preferences and requirements of each patron group. Religious iconography and allusions often crept into the formal portraits and had an indelible impact in Mexican art history. The legacy of Catholic imagery and its reverence continues to be felt in many Latin American, Latino and Chicano art practices, and has previously appeared in Montoya's work. Thus, the art historical and social references alluded to in *Casta 1* establish the image as a capstone, while serving to remind us of the project's origins.

In *Casta 1* we see several generations of a family in New Mexico gathered in their community chapel. Central to the photograph are two children who are altar servers, presumably participating in a mass or prayer service. The pews on each side are occupied by a handful of family members, perhaps their mother, parents and grandparents. All of the adults focus their attention on the children, as a girl carries the traditional cross and a young boy raises the Bible over his head. Their audience's expressions range from subdued admiration to contemplation, suggesting a pensive, heartfelt spirituality. Their religious devotion is obvious, as seen both in their faces and their choice of location.

As in most of the *Nuestra "Calidad"* series, architecture plays a pivotal role in creating context for the image. The chapel itself is humble, made of wood and adobe, yet the altar and surrounding artwork appear to have historic significance. Their patina is that of fine art in a museum in that they appear aged but well maintained. The woodwork on the frames is finely carved, and the scenery of the paintings is abundant with detail. The family selected this chapel because it has been their place of worship for generations and is centuries old. Their participation in the project was largely born out of their own belief that they are descendants of some of the original Spaniards who settled in New Mexico. Thus, they have deep Catholic roots as well as regional and local ties.

In the series *Nuestra "Calidad"*, Delilah Montoya uses photography and DNA analysis to produce 21st century family portraits. Although this body of work is fundamentally rooted in eighteenth-century Spanish casta painting, the sixteen photographs illustrate the contemporary resonance of colonial concepts of race and class. Examined individually, the works present nuanced, intimate glimpses of family life in personal domestic spaces and hyperlocal details. Yet taken as a whole, Nuestra "Calidad" is a conceptual project that makes visible the persistence of our misconceptions about race and ethnicity, and suggests a universal desire to better know ourselves.

Were we to endeavor to summarize the findings of Montoya's research, we

might be tempted to make sweeping generalizations drawn from the scientific DNA research and speculative readings of the photographs. While this approach might bring to light some superficial commonalities across the families (generational differences, regional or geographic disparity and class identity, to name a few), it overlooks a key component of the work. That is, the photographs of *Nuestra "Calidad"* present one moment and one perspective of a family's life. Although the families are complicit participants, the images are staged and thus exist somewhere between documentary and formal portraiture. The artist herself discloses that many key details about her subjects are invisible or hidden in the compositions. Absent from the images are the conversations that were happening in front of the lens, the backstory as to how family members are related, actual facts and figures about family finances and their own articulation about why they chose to participate. Montoya's photographs are rich with details and contextual clues yet can never fully capture the narrative history of the people they depict.

As the artist talks about the work and her conversations with the families, it is evident that discretion is important to her, and to her vision for the project. Thus, like the original casta paintings, the photographs of *Nuestra "Calidad"* are two-dimensional renderings of subjects that occupy real space and time. This flattening of their personas is both an illustration of portraiture inefficiencies and a conceptual exploitation of this very fault. By establishing the work's relationship to casta paintings, Montoya predisposes her viewer to a close reading of the works through a lens of race and class. Yet in many ways this is no different from how we already consume visual media. The artist does not dictate how we see things, but instead activates a way of seeing that we are intimately familiar with. The conclusions that we draw and the archetypes that we imagine are products of our own worldview, and implicate us in a complex web of race and class questions.

1  See "Chapter 2: Counting Multiracial Americans" http://www.pewsocialtrends.org/2015/06/11/chapter-2-counting-multiracial-americans/

2  http://www.delilahmontoya.com/ContempCasta/casta.html

3  James M. Córdova and Claire Farago, "Casta Paintings and Self-Fashioning Artists in New Spain," pg. 139

4  https://genographic.nationalgeographic.com/about/

5  http://www.delilahmontoya.com/ContempCasta/casta.html

Delilah Montoya

# Contemporary Casta Portraiture: *Nuestra "Calidad"*

As a Chicana artist, my own personal quest in image-making is the discovery and articulation of Chicano culture, and the icons which elucidate the dense history of Aztlán. My artistic vision is an autobiographical exploration, but one that has far-reaching implications for my community and the preservation of its unique history. As a Chicana artist, my work, interpreted as an alternative to the mainstream, stands as a personal statement that evokes an identity. I aspire to originate the artist's voice. My work, however, is more than a personal statement, for it is rooted in and informed by history.

*Contemporary Casta Portraiture: Nuestra "Calidad"* is an investigation of cultural and biological forms of "hybridity." Looking at this as a signifier of colonialism, the photographic portraits mimic the aesthetic and cultural markers suggested by the casta paintings of the eighteenth century in present-day familial settings of New World multicultural communities.

The idea is to witness the resonance of colonialism as a substructure of our contemporary society that was constructed by an imposition of sovereignty. According to Reinhardt this is a "wholly optic affair":

> ...the optical unconscious can alert us to complexities and perplexities often overlooked in analyses of certain important features of politics and visual culture.
>   One of these features is "race," a visual artifact carrying a singularly powerful charge. Whether as ideology, institution or lived experience, race is of course not made only by visual means, but its inequities and indignities remain tightly bound to ways of seeing human difference and organizing the perceptual field. To the rich critical tradition arising from that insight, [Walter] Benjamin's optical unconscious offers at once a

contribution and a potentially destabilizing challenge. On the one hand, stressing the unseen elements in visual experience may broaden our sense of how race is constructed. On the other, it poses the puzzle of how the invisible can be part of "visual construction." [1]

Sovereignty relies on orchestrating gazes for the display of power (from imperial spectacles to televised political addresses to walls erected at national borders) that ultimately promotes a collective body. Yet through the "optical unconscious"[2] subtle intransigent discourses can be detected. Colonial discourse produces the colonized social reality as one that is never fixed into an era, but instead that reality passes on in time as appropriated, translated, re-historicized and read as new signifiers. Clearly this process riddles through the colonial casta painting tradition as well as the present *Contemporary Casta Portraiture: Nuestra "Calidad."*

Colonial society emerged out of a mixed ethno-racial social structure. In the years following the conquest of Mexico in 1521, most people in the New World fell into three distinct ethno-racial categories: First Nation (indigenous people), peninsular Spaniards (European) and Africans (both enslaved and free). By the late seventeenth century, these categories broke down quickly and a caste system based on miscegenation was defined throughout the New World colonial realm. More specifically, as the Colonial discourse was deployed through surveillance, that is as the gaze of the colonizer towards colonial bodies, a socio/racial hierarchy conformed to the European ideas of the "other."

Casta paintings presented a group of sixteen portraits, with each painting depicting a racial mixing or *mestizaje* of the population found on the American continents. The basic formula illustrated a married couple with one or two children, who were rendered in a domestic or occupational environment. An inscription describing the ethno-racial make-up of the mother, the father and the child(ren) usually appeared in writing within the painting or above the family unit. The offspring was given a unique ethno-racial definition. Each casta is given a classification, such as "mestizo" (*de india y español*) or "mulato" (*de negra y español*). The castas illustrate a social hierarchy, with the peninsular Spaniard (*español*) located above the First Nation (*indio*) and African (*negro*)

family units. The lighter or more European the ethno-racial mix, the closer it is positioned to the peninsular Spaniards.

There were two conditions that separated the Spanish elite from "others": non-elite that was raza/lineage and calidad/status. In "Imaging Identity in New Spain," Magalí M. Carrera explains,

> The Spanish association of raza with purity of blood and blood lineage was adapted to fit the specific circumstances of the conquest. In Mexico, the Spaniards found themselves in the minority among the Aztec-Mexica, who had achieved a certain degree of social complexity. They acknowledged the existence of social and political hierarchy among the indigenous people and recognized the caciques, Indian nobles, as having civil and social rights and privileges. In fact, following the logic of raza, Spaniards believed that Indian blood was not blemished by infidel blood, thus, was essentially a pure blood. ...Spanish men and Indian women that produced mestizo offspring resulted in diluted [status] but not polluted blood [lineage]... by the seventeenth century it was thought that the union of mestizo and Spaniard resulted in castizo offspring . . . the offspring of a castizo and Spaniard returned to Spanish "calidad, meaning pure Spanish blood." This was not the case for the mixing of Spanish or Indian blood with that of black Africans.[3]

Once descendants of enslaved Africans were freed they began to participate as artisans or in markets of the general economy. However the Spanish crown controlled the African presence in America through laws barring them from military guilds and quarters of Mexico City. Black Africans and mulattos were forbidden to wear gold, silk, pearls or lace. Mixed race marriages with African bloodlines were considered a permanent stain that polluted raza/linage of a family.

At the time of baptism, the colonist was either written into the book of the Español [Spanish], Indígena [Indigenous] or Casta [the diluted and black lineage.] The book separated the ones who paid tribute from those who received privileges. Castas and non-cacique indigenous populations paid

tribute while the Spaniard and cacique did not.

The fact that the majority of casta paintings are located in Europe rather than the Americas indicates they were commissioned by viceroys and clergy to describe the colonies' various racial mixtures to the King. Katzew writes, "[Colonial] artists worked for an implied audience, and their paintings encode the expectations of that audience" (203). The casta "encode" shifted from first as nomenclature aligned with a strong sense of "criollismo" to an examination of material culture, pointing towards national identity; it finally ends abruptly after Mexico gained its independence in 1821.[4]

Historians have linked the genre paintings produced after 1760 to the influence of the Spanish American Enlightenment, thus marking a shift in production from visual classification of casta types to illustrating colonial material culture. They reveal details of architectural space and home life and present meticulous depictions of everyday objects, native flora and fauna and foodstuffs. During the 1760s Bourbon reforms, these depictions speak not only about a fascination with race, but also about the leading philosophical and scientific preoccupations. The reforms shift the scope of casta painting from demonstrating a medieval hierarchy to "illustrating the endless racial permutation that took place in the colonies."[5]

In the *Location of Culture*, Homi K. Bhabha discusses colonial discourse as producing a colonized social reality based on mimicry, ambiguity and hybridity. The colonizer defines and is defined by the colonized; each cannot exist without the other. The stereotype creates an "identity" that develops from the complete dominance of the other, as well as from the anxiety of the dominant, thus recognizing the differences while at the same time disavowing them. Mimicry appears when the colonized imitate and take on the culture of the colonizer: "the observer becomes the observed and 'partial' representation rearticulates the whole notion of identity and alienates it from essence."[6] Bhabha continues by envisioning the colonized Other as positioned in the binary space between the "us" and Other dichotomy. He concludes: "Colonial mimicry is the desire for a reformed recognizable Other, as subject of difference that is almost the same, but not quite. Mimicry is . . . a complex strategy of reform, regulation and discipline which 'appropriates' the Other as its

visualized power" (Bhabha 85–86). Bhabha's concepts help us understand the casta system not only as a construct of raza/lineage and calidad/status but as an ambiguous term that confirms the existence and working of mimicry and hybridity in eighteenth-century colonial society.

Even though the casta structure suggests an ethno-social segregation, one's casta could be changed by the individual's ability to mimic the elite class through marriage, entrepreneurship, education or the arts. A casta designation could be and was contested when one married into a higher class, owned a successful business, acquired an academic education or mastered one of the arts, including entertainment and sports. The castas' ethno-social classes were fluid, much to the dismay of the peninsular/creole Spaniards who attempted to maintain control by keeping the plebeians in separate and distinct spheres out of fear that non-elite classes would and could pass as one of them. They feared the bloodlines would become polluted, but more importantly that they could lose control.

Like the colonial casta paintings, *Contemporary Casta Portraiture: Nuestra "Calidad"* represents household units; however, it does not define the members by means of colonial terminology. Instead, the families agree to share the results of their DNA test to demonstrate their deep and regional ancestry. In contrast, the casta paintings visualized the ethno racial/social hierarchy as a "natural order."

*Contemporary Casta Portraiture: Nuestra "Calidad"* is a photographic study of selected families from Texas and New Mexico whose ancestry emerges from New World ethno-racial mixtures. The DNA test that was employed in my research suggests a sort of contemporary mimic of the casta painting. Yet like all mimicry, there is distance in that the contemporary casta families collaborated with me as the artist in representing their family units. They were asked to be actors in their own lives, leaving the viewer to read what the families chose to reveal. Rather than a representation of a constructed identity to fit an assumed description, as in the original casta paintings, simply put, the contemporary families represented themselves.

The attempt is to witness an "optic unconscious" revealed by DNA that points to a racially mixed ancestry that in turn references a colonial past.

I believe this verifies that the colonial caste system still exists as a footprint in our contemporary culture, and the presented portrait of families from the colonial past of the Americas and America serves as a document. "Our America" is not only connected historically, but also genetically and culturally. Colonial reality resonates in our cultural, social and racial identities and is not only evidenced through DNA but in our environments, as well. The family portraits are taken during a one-hour session either at the family's public or private space. Then, different photographic decisive moments are merged through Photoshop layers to create a family portrait. The names of the families remain anonymous so as to direct the viewer's attention away from the specific individuals and to the family unit as a genre.

This project serves as a reminder that the mass incarceration of American colonial communities (redefined as immigrants/illegal aliens or offenders) held in detainment-prisons throughout the United States demonstrates how sovereignty still struggles to control the colonial body. Casta paintings and the Genome DNA Project attempt to give a fixed identity, to mirror a "natural truth." Yet the castas also remind us how "ambiguity brings chaos to all dreams of order." (Carrera 153)

Production of *Contemporary Casta Portraiture: Nuestra "Calidad"* is funded in part by grants from Transart Foundation, Artist to Artist Fund, New Mexico Artist Match Fund, Hatch Fund, The Idea Fund, Artadia 2015 ISCP New York Residency, UH Center for Mexican American Studies and the University of Houston Small Research Grant, as well as contributions from Chon Noriega, Gilberto Cárdenas, Joe Aker, Surpik Angelini, Celia Muñoz, Sam Coronado, Ann Tucker, Connie Cortez, Ann Leimer, Zoanna Maney, Tere Romo, Dee Ann McIntyre and Rick Custer. With so much gratitude for the donors' encouragement and support, they are thanked for their generosity. Also I thank Holly Barnett Sanchez, Surpik Angelini and Mia Lopez for taking time to write thoughtful, informative essays and Beckham Dossett for the book design in support of this work. Most important I am obliged to all the casta families who opened their homes and minds in bringing this project to fruition.

1 Mark Reinhardt, "Vision's Unseen: On Sovereignty, Race, and the Optical Unconscious." https://muse.jhu.edu/article/595837

2 The optic unconscious is based on how we routinely miss much of what unfolds in our visual field. The optic unconscious is that unseen knowledge that is rendered by technology, i.e., the image created by an explosion seen not by the naked eye rather the fast shutter speed of a camera. In the case of Contemporary Casta Portrait it is the ethno/racial heritage recorded through DNA testing and not by looking directly at the family portrait.

3 Magali M. Carrera, *Imaging Identity in New Spain* (Austin: University of Texas Press, 2003): pp. 12–13.

4 It was the Spanish Creoles who ended casta painting production because the painting genre illustrated their class among mixed-blooded peoples.

5 Ilona Katzew, *Casta Paintings: Images of Race in Eighteenth-Century Mexico* (New Haven: Yale University Press, 2004). pp. 103

6 Homi K. Bhabha, *The Location of Culture* (London: Routledge, 1994). pp. 89

# Geno 2.0 Next Generation National Geographic Project

By participating in the Geno 2.0 Next Generation National Geographic Project, all the selected families share their ancestry-relevant DNA "markers" with Contemporary Casta Portraiture: Nuestra "Calidad." The DNA markers are the result of small variations or mutation in their genome, hence, setting each family group apart from each other. These mutations are rare events, yet once they occur, they are passed down to subsequent generations. The Geno 2.0 project analyzes these markers along with the family's entire genome to determine its deep, regional and hominin ancestry.

The deep ancestry expresses the maternal and paternal branches or haplogroups that the family belongs to. Because each male has mitochondrial (mtDNA) and Y chromosomes, the father or son carries the deep ancestry of both his mother and father. However, a female has only mitochondrial (mtDNA), so she carries only her mother's deep ancestry. Given this fact, some of the casta families' DNA tested only the son because he carries both the mother's and the father's branch; in the absence of a son, both parents were tested—sometimes the mother's brother was tested to include the paternal branch of the mother's line. When a mother is head-of-household with only daughters, one daughter is tested and the male branch is naturally excluded. By examining the deep ancestry through haplogroups, an ancient migration beginning in East Africa 100,000 years ago and ending around 1,000 years ago is tracked for each family. In many cases you will see lineages migrated out of East Africa around 100,000 years ago and then, through the generations' ancestral routes, end 1,000 years ago throughout various continents.

The regional ancestry is based on DNA markers across the entire genome, representing the contributions from both the mother's and father's DNA. The regional ancestry gives a rough biogeographical breakdown of percentage of DNA shared between global populations. Gene tests are divided into 9 biogeographic regions. These references extend 6 generations back; however, any percent less than 2 is not traced. For example, Casta 9 shows the father's maternal haplogroup to be Native American, but his regional ancestry does not trace Native American markers to one of the regions because the percentage is too slight to be counted.

ANCESTRAL MIGRATION

MOTHER'S BROTHER

MATERNAL   - - - - - - - - - -

PATERNAL   ——————————

FATHER

MATERNAL   - - - - - - - - - -

PATERNAL   ——————————

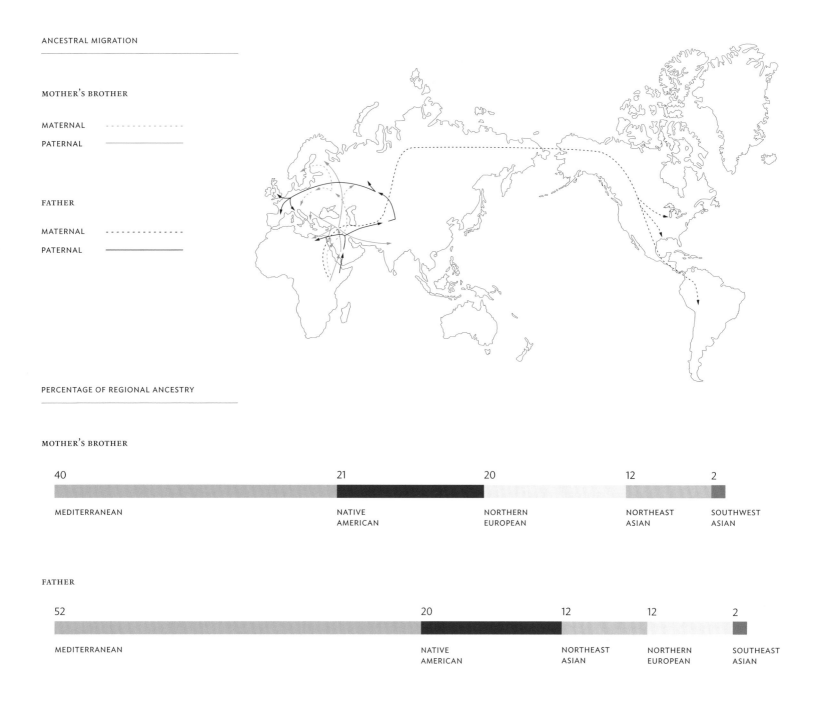

PERCENTAGE OF REGIONAL ANCESTRY

MOTHER'S BROTHER

40                              21              20              12      2

MEDITERRANEAN                   NATIVE          NORTHERN        NORTHEAST   SOUTHWEST
                                AMERICAN        EUROPEAN        ASIAN       ASIAN

FATHER

52                                      20          12      12      2

MEDITERRANEAN                           NATIVE      NORTHEAST   NORTHERN    SOUTHEAST
                                        AMERICAN    ASIAN       EUROPEAN    ASIAN

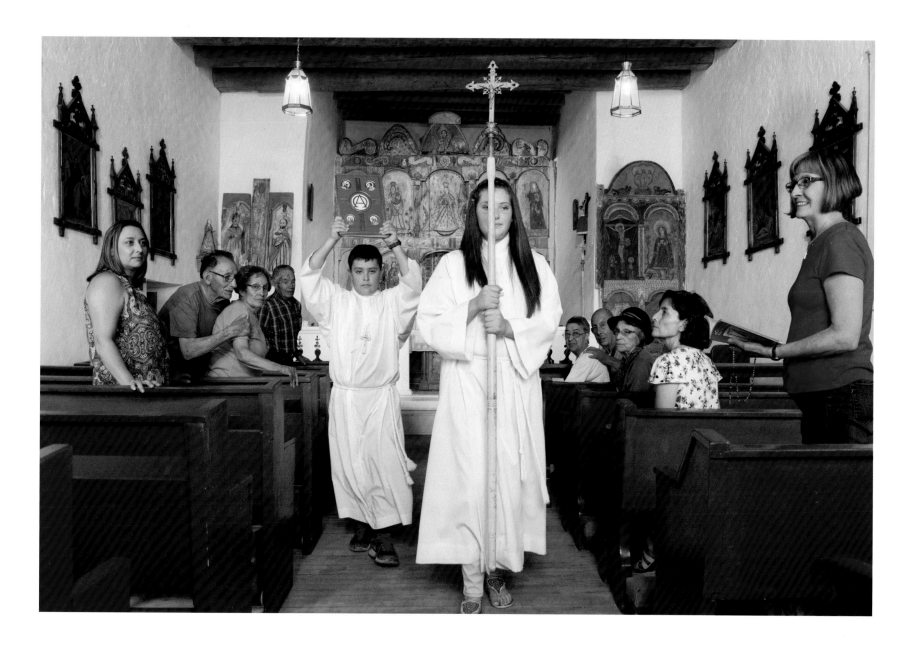

**CASTA 1**

In this extended family, the father (far left) and the mother's brother (right) were DNA tested for their casta portrait.

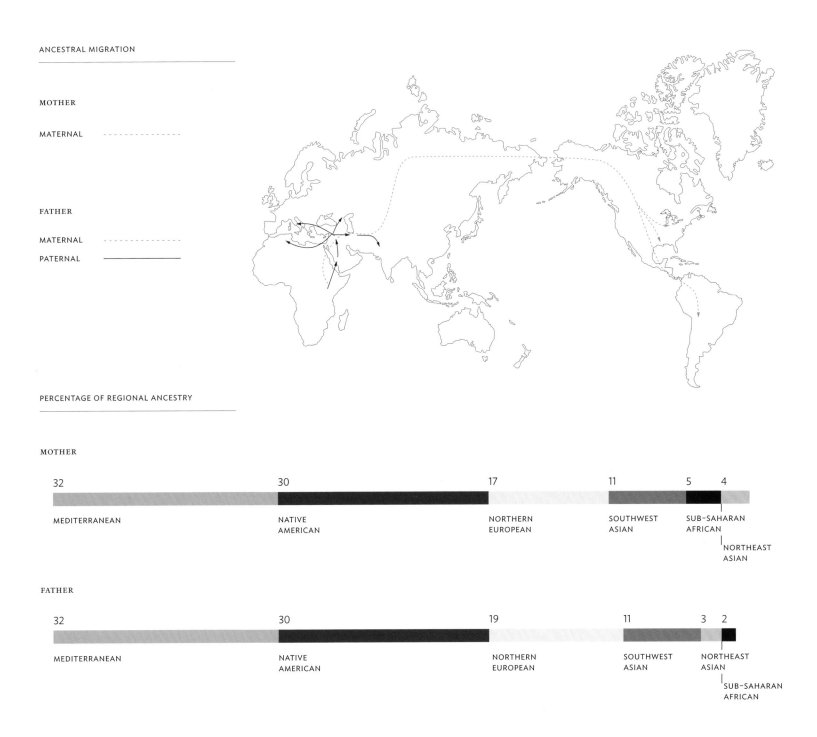

ANCESTRAL MIGRATION

MOTHER

MATERNAL    - - - - - - - - - - -

FATHER

MATERNAL    - - - - - - - - - - -

PATERNAL    —————————

PERCENTAGE OF REGIONAL ANCESTRY

MOTHER

| 32 | 30 | 17 | 11 | 5 | 4 |
|---|---|---|---|---|---|
| MEDITERRANEAN | NATIVE AMERICAN | NORTHERN EUROPEAN | SOUTHWEST ASIAN | SUB-SAHARAN AFRICAN | NORTHEAST ASIAN |

FATHER

| 32 | 30 | 19 | 11 | 3 | 2 |
|---|---|---|---|---|---|
| MEDITERRANEAN | NATIVE AMERICAN | NORTHERN EUROPEAN | SOUTHWEST ASIAN | NORTHEAST ASIAN | SUB-SAHARAN AFRICAN |

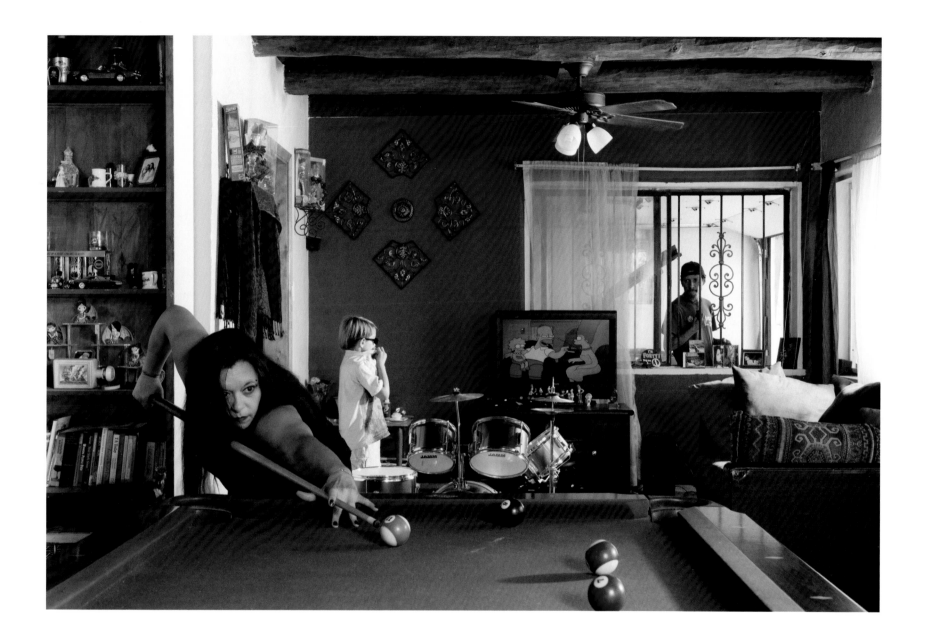

**CASTA 2**
Both parents were DNA tested for their family casta portrait.

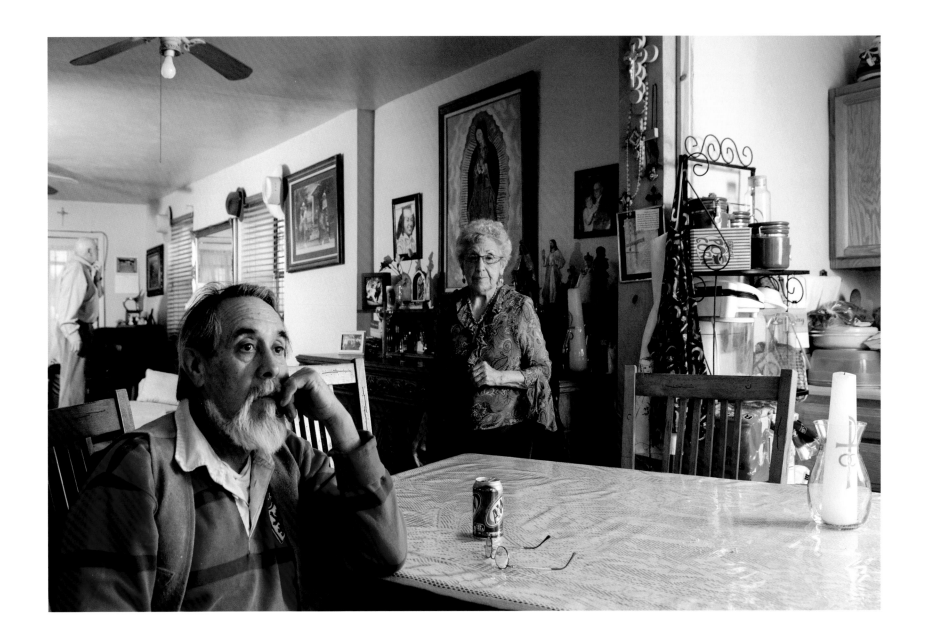

**CASTA 3**
The son (in front) was DNA tested for their family casta portrait of a mother and two sons.

SON

MATERNAL --------------

PATERNAL ───────────

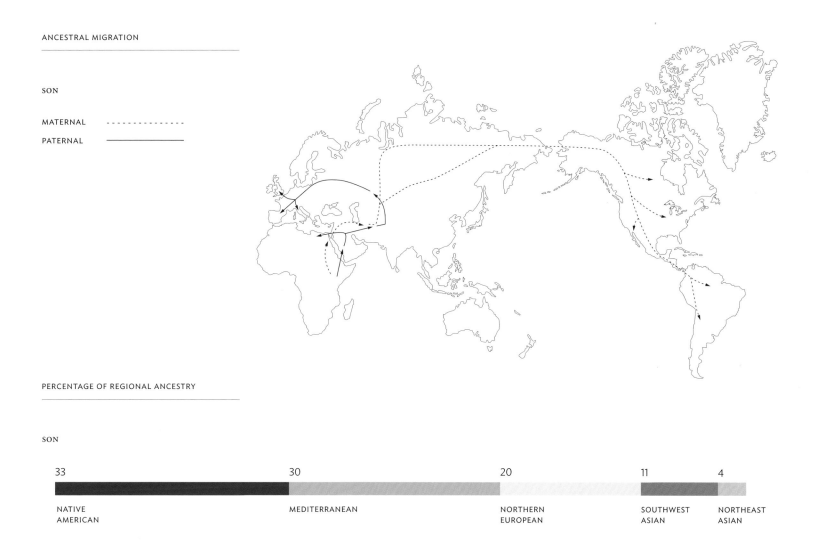

PERCENTAGE OF REGIONAL ANCESTRY

SON

| 33 | 30 | 20 | 11 | 4 |
|----|----|----|----|---|

NATIVE
AMERICAN

MEDITERRANEAN

NORTHERN
EUROPEAN

SOUTHWEST
ASIAN

NORTHEAST
ASIAN

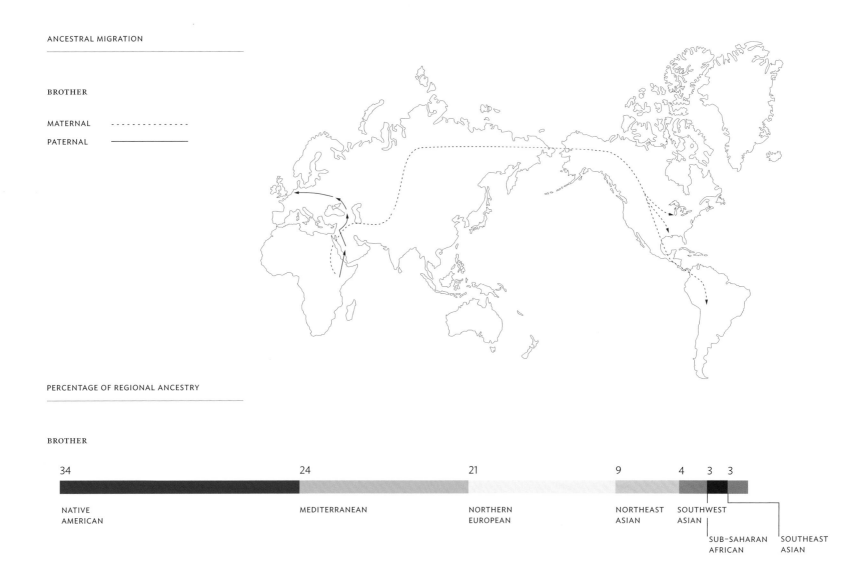

BROTHER

MATERNAL   - - - - - - - - - - - -
PATERNAL   ——————————

PERCENTAGE OF REGIONAL ANCESTRY

BROTHER

| 34 | 24 | 21 | 9 | 4 | 3 | 3 |
|----|----|----|---|---|---|---|

NATIVE
AMERICAN

MEDITERRANEAN

NORTHERN
EUROPEAN

NORTHEAST
ASIAN

SOUTHWEST
ASIAN

SUB-SAHARAN
AFRICAN

SOUTHEAST
ASIAN

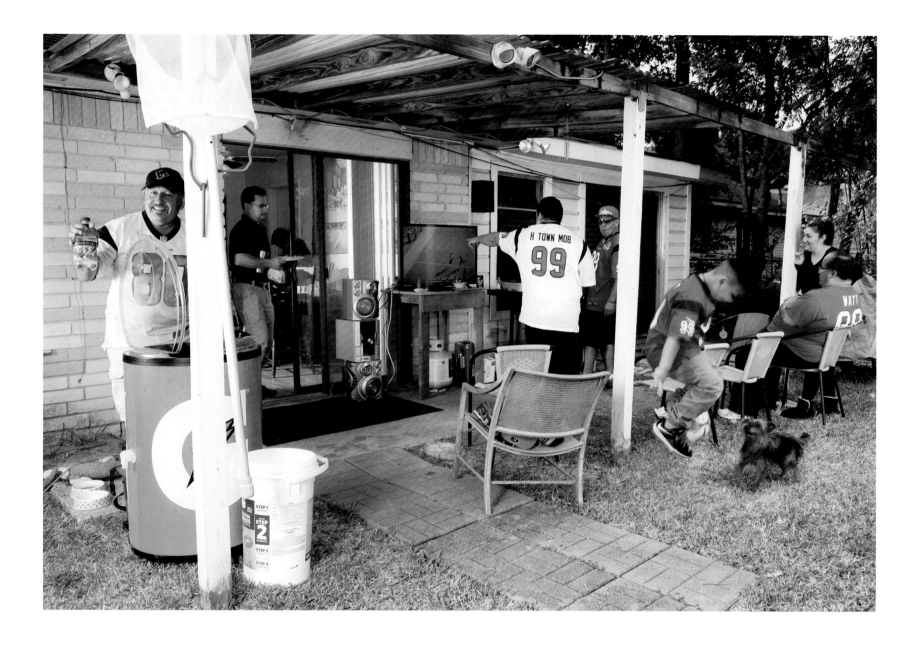

**CASTA 4**

Photographed with his four brothers, a single father (right-center facing forward) was DNA tested for their extended family casta portrait.

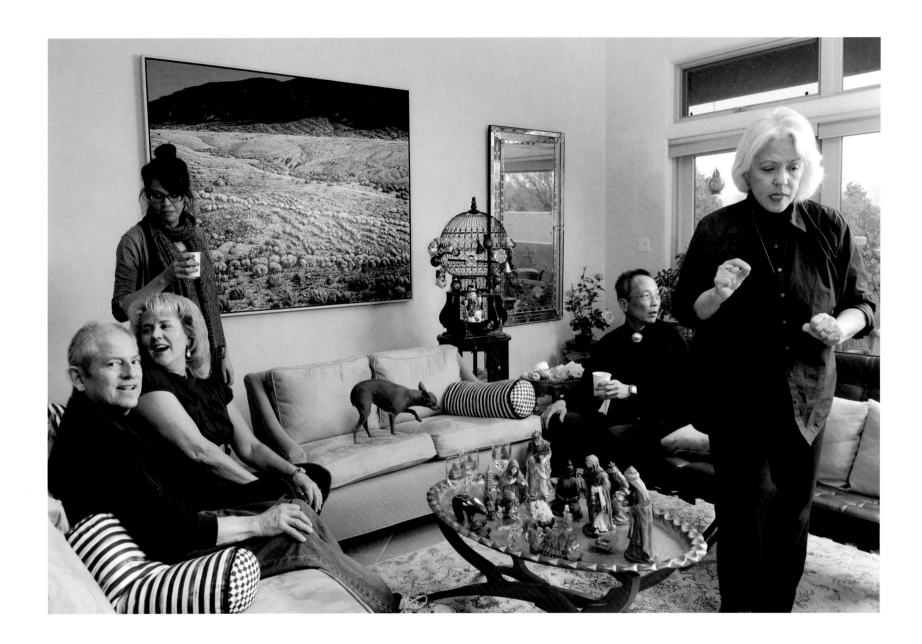

**CASTA 5**

This modern extended family casta portrait of mother and daughter includes the stepfather along with a maternal first cousin and his wife. The maternal first cousin (left) as well as a paternal first cousin (not depicted) was DNA tested.

ANCESTRAL MIGRATION

_____

MATERNAL FIRST COUSIN

MATERNAL     - - - - - - - - -

PATERNAL     _____

PATERNAL FIRST COUSIN

MATERNAL     - - - - - - - - -

PATERNAL     _____

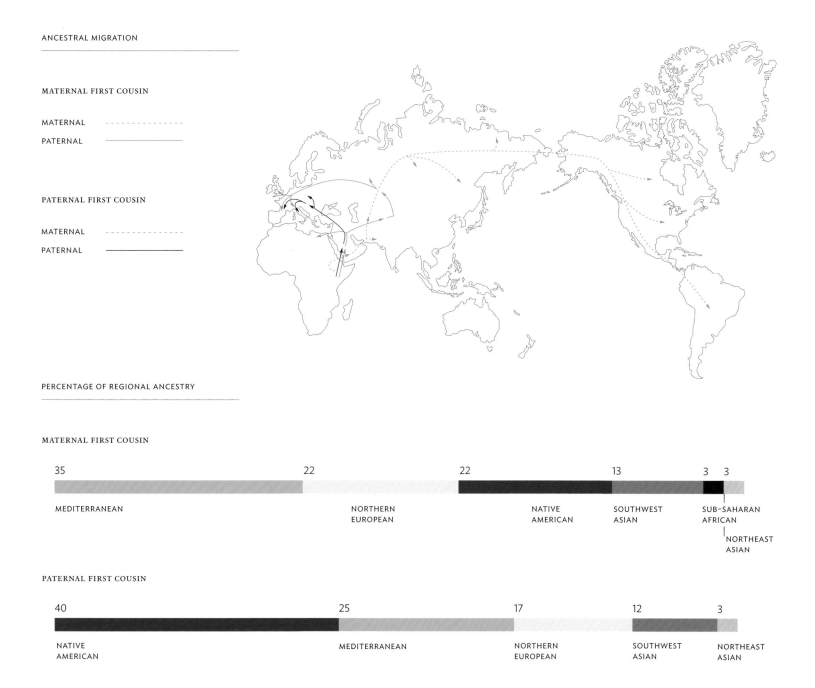

PERCENTAGE OF REGIONAL ANCESTRY

_____

MATERNAL FIRST COUSIN

| 35 | | 22 | 22 | | 13 | 3 | 3 |

MEDITERRANEAN                    NORTHERN          NATIVE        SOUTHWEST    SUB-SAHARAN
                                 EUROPEAN          AMERICAN      ASIAN        AFRICAN

                                                                             NORTHEAST
                                                                             ASIAN

PATERNAL FIRST COUSIN

| 40 | | 25 | 17 | 12 | 3 |

NATIVE                           MEDITERRANEAN     NORTHERN      SOUTHWEST    NORTHEAST
AMERICAN                                           EUROPEAN      ASIAN        ASIAN

ANCESTRAL MIGRATION

MOTHER

MATERNAL ------------

FATHER

MATERNAL - - - - - - -

PATERNAL _____

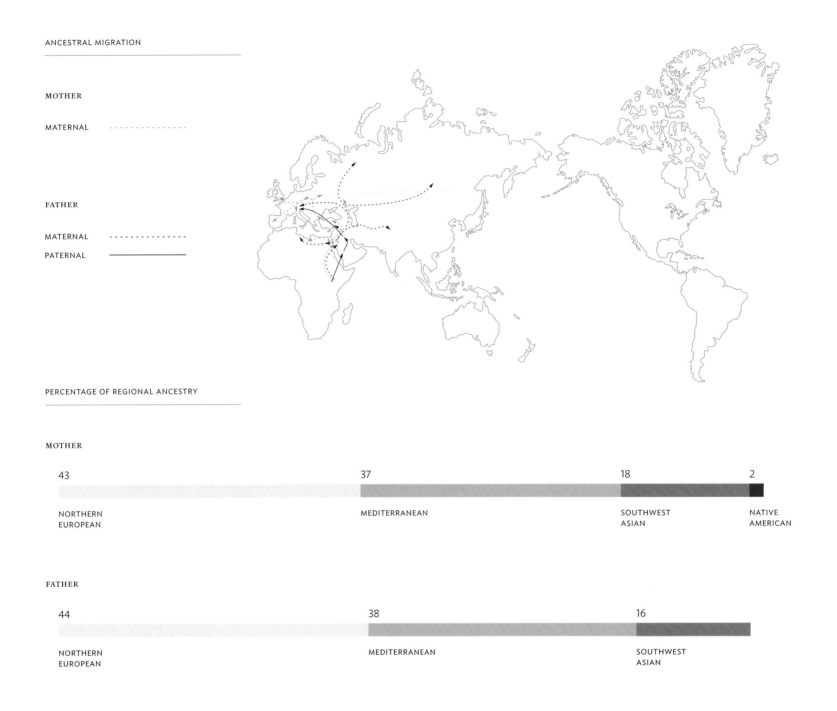

PERCENTAGE OF REGIONAL ANCESTRY

MOTHER

| 43 | 37 | 18 | 2 |
|---|---|---|---|
| NORTHERN EUROPEAN | MEDITERRANEAN | SOUTHWEST ASIAN | NATIVE AMERICAN |

FATHER

| 44 | 38 | 16 |
|---|---|---|
| NORTHERN EUROPEAN | MEDITERRANEAN | SOUTHWEST ASIAN |

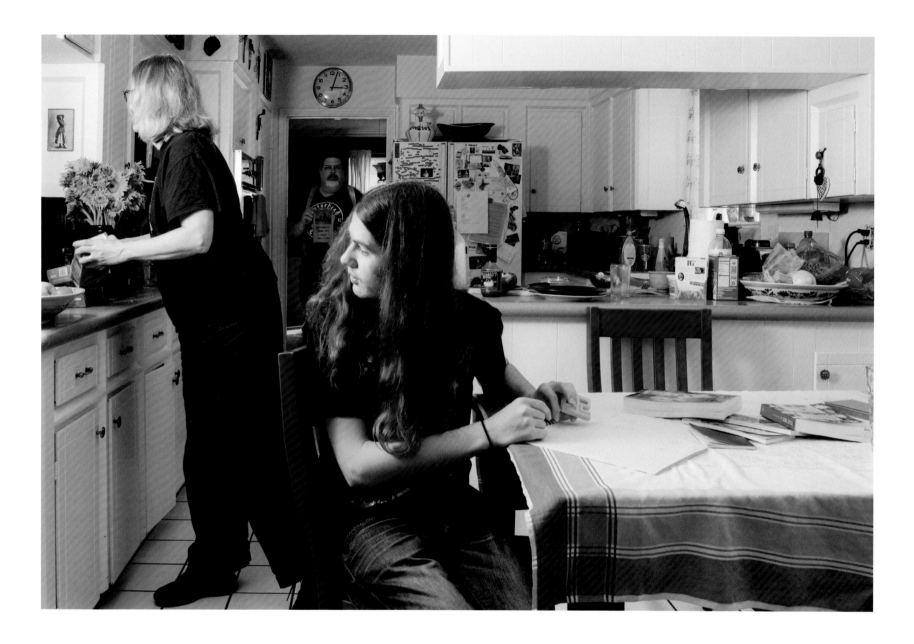

**CASTA 6**
Both parents were DNA tested for their family casta portrait.

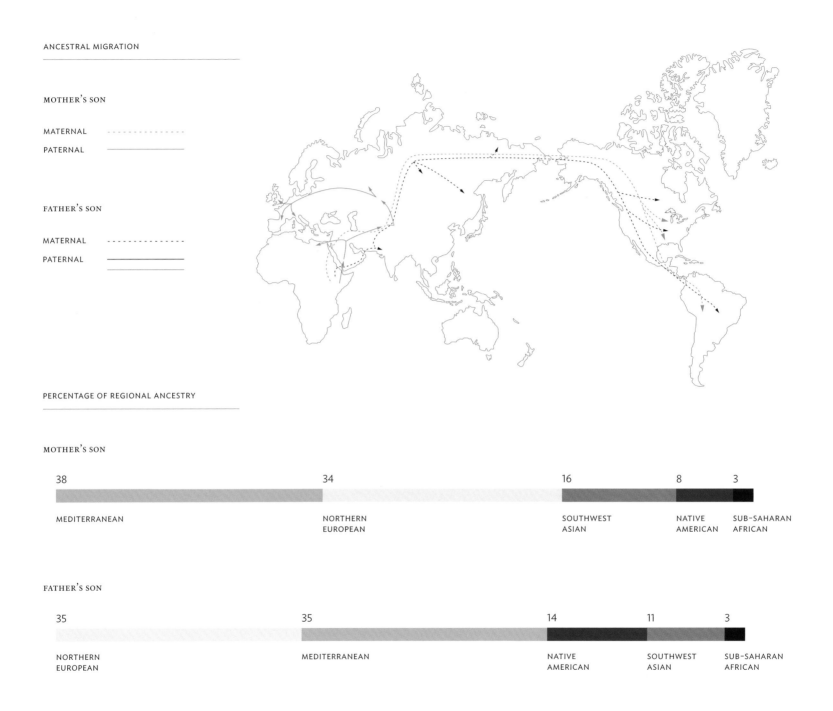

ANCESTRAL MIGRATION

MOTHER'S SON

MATERNAL

PATERNAL

FATHER'S SON

MATERNAL

PATERNAL

PERCENTAGE OF REGIONAL ANCESTRY

MOTHER'S SON

38  34  16  8  3

MEDITERRANEAN  NORTHERN EUROPEAN  SOUTHWEST ASIAN  NATIVE AMERICAN  SUB-SAHARAN AFRICAN

FATHER'S SON

35  35  14  11  3

NORTHERN EUROPEAN  MEDITERRANEAN  NATIVE AMERICAN  SOUTHWEST ASIAN  SUB-SAHARAN AFRICAN

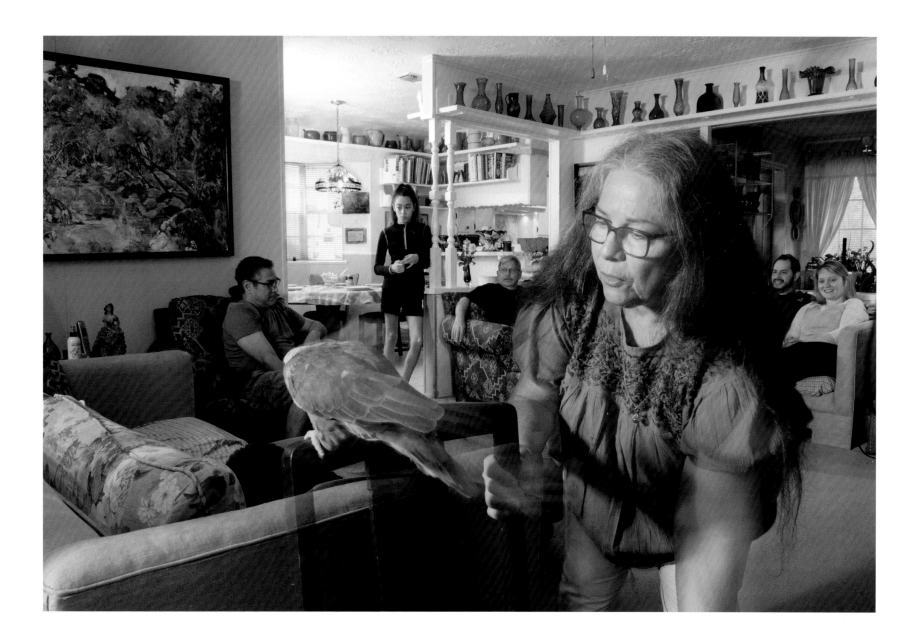

**CASTA 7**
Each son (far left and right) from previous marriages was DNA tested for their extended modern family casta portrait.

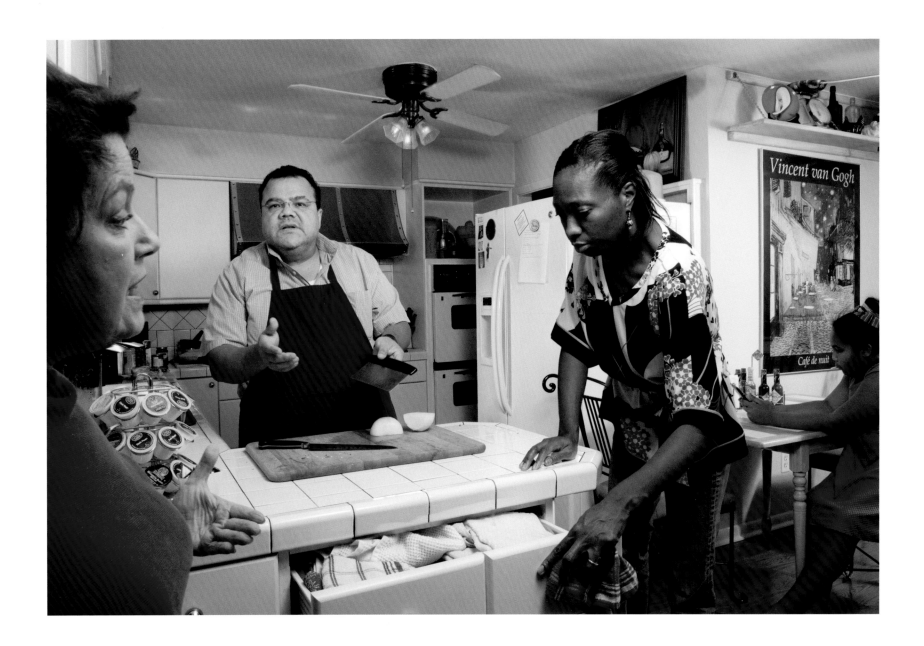

**CASTA 8**
Both parents (center) were DNA tested for their family casta portrait.

ANCESTRAL MIGRATION

MOTHER

MATERNAL    - - - - - - - - - - -

FATHER

MATERNAL    - - - - - - - - - - -
PATERNAL    ——————————

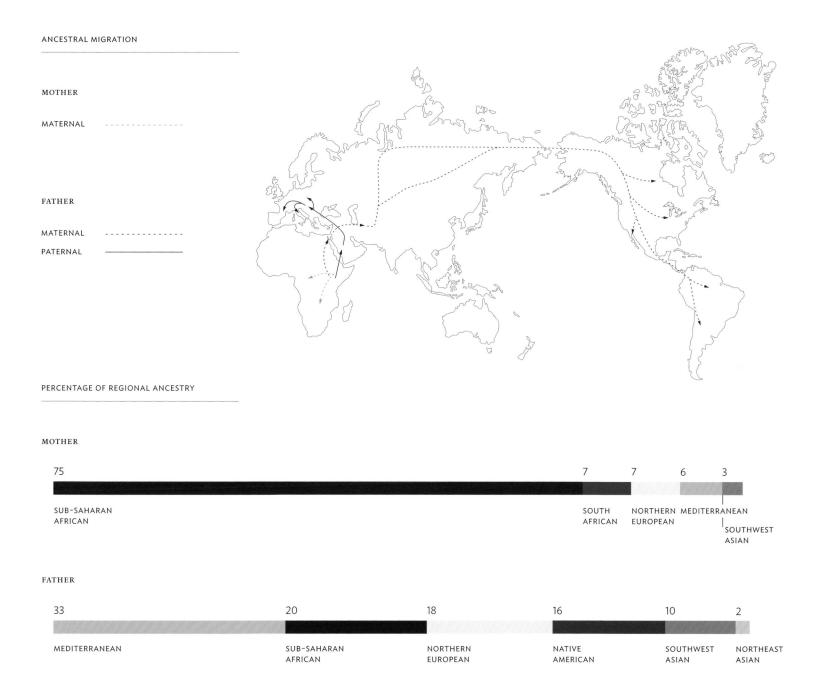

PERCENTAGE OF REGIONAL ANCESTRY

MOTHER

75                                                          7       7      6      3

SUB-SAHARAN                                              SOUTH   NORTHERN  MEDITERRANEAN
AFRICAN                                                 AFRICAN  EUROPEAN
                                                                              SOUTHWEST
                                                                              ASIAN

FATHER

33                        20              18            16            10          2

MEDITERRANEAN         SUB-SAHARAN      NORTHERN      NATIVE        SOUTHWEST    NORTHEAST
                      AFRICAN          EUROPEAN      AMERICAN      ASIAN        ASIAN

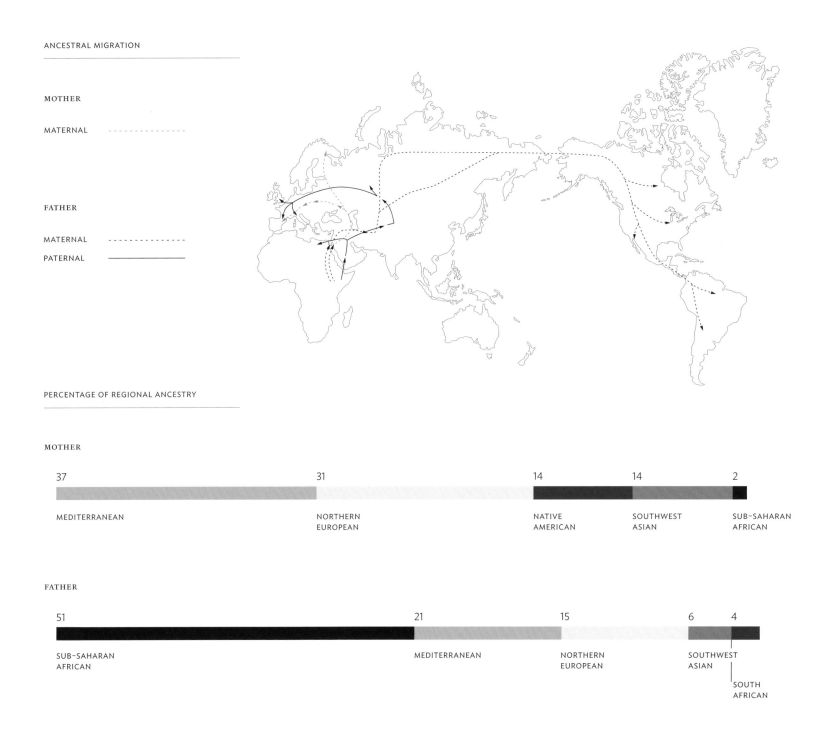

ANCESTRAL MIGRATION

MOTHER

MATERNAL          - - - - - - - -

FATHER

MATERNAL          - - - - - - - -
PATERNAL          _____

PERCENTAGE OF REGIONAL ANCESTRY

MOTHER

| 37 | 31 | 14 | 14 | 2 |
|---|---|---|---|---|
| MEDITERRANEAN | NORTHERN EUROPEAN | NATIVE AMERICAN | SOUTHWEST ASIAN | SUB-SAHARAN AFRICAN |

FATHER

| 51 | 21 | 15 | 6 | 4 |
|---|---|---|---|---|
| SUB-SAHARAN AFRICAN | MEDITERRANEAN | NORTHERN EUROPEAN | SOUTHWEST ASIAN | SOUTH AFRICAN |

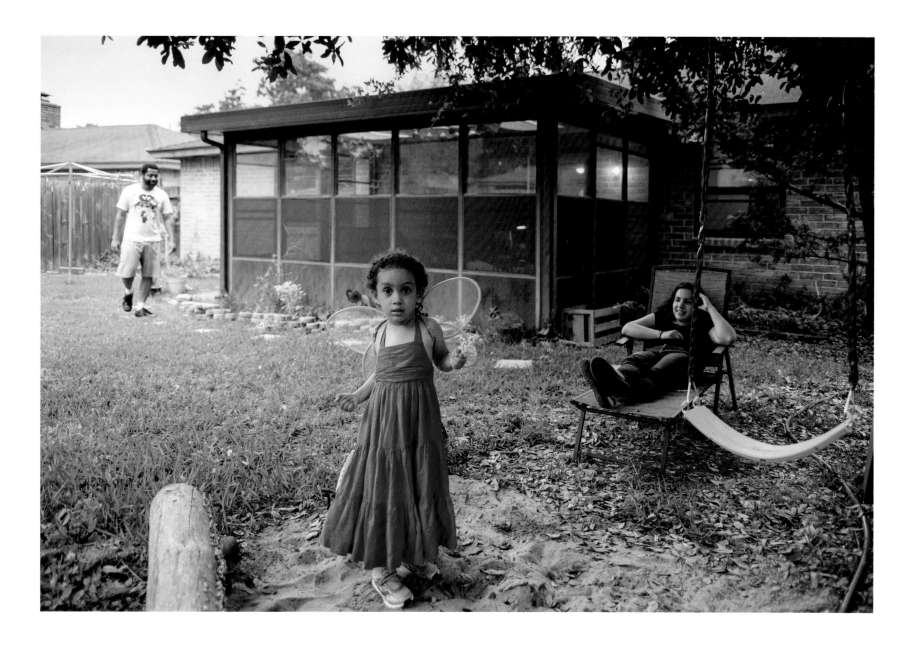

**CASTA 9**

Both parents were DNA tested for their family casta portrait.

ANCESTRAL MIGRATION

MOTHER

MATERNAL - - - - - - -

PATERNAL ————————

FATHER

MATERNAL - - - - - - -

PATERNAL ————————

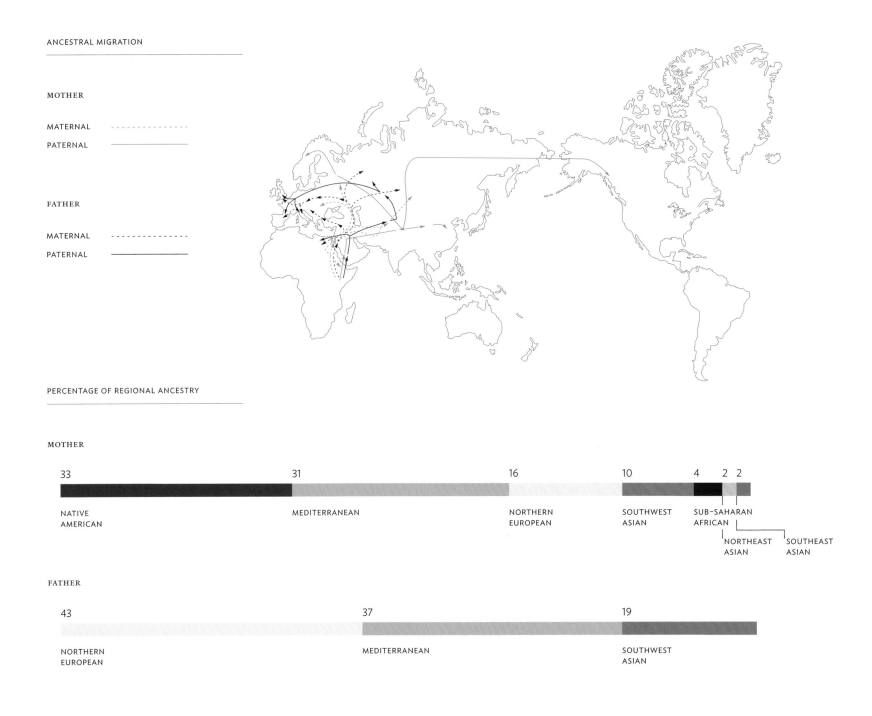

PERCENTAGE OF REGIONAL ANCESTRY

MOTHER

| 33 | 31 | 16 | 10 | 4 | 2 | 2 |

NATIVE
AMERICAN              MEDITERRANEAN                NORTHERN          SOUTHWEST    SUB-SAHARAN
                                                  EUROPEAN          ASIAN        AFRICAN

NORTHEAST        SOUTHEAST
ASIAN            ASIAN

FATHER

| 43 | 37 | 19 |

NORTHERN
EUROPEAN                MEDITERRANEAN                SOUTHWEST
                                                     ASIAN

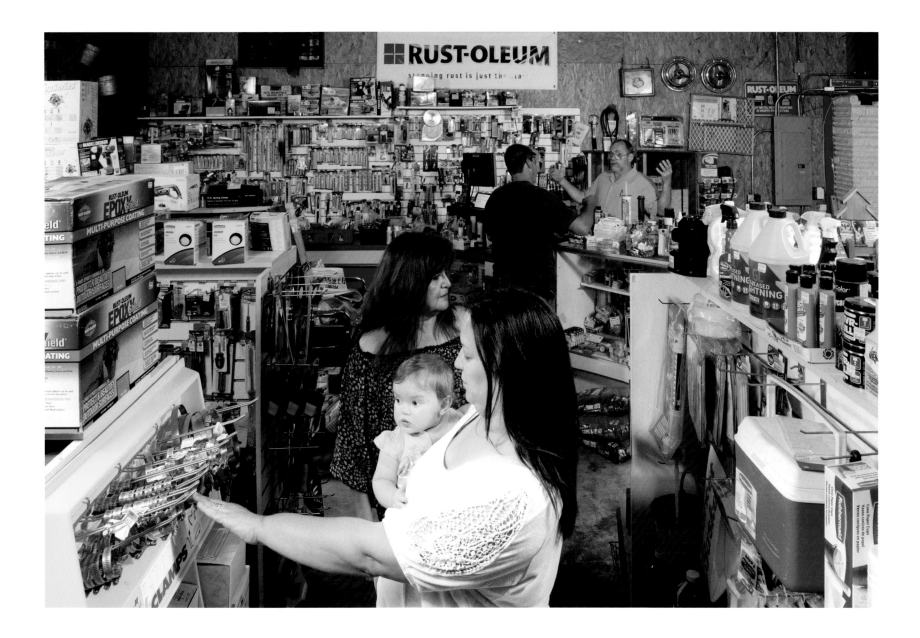

**CASTA 10**

This modern extended family casta portrait foregrounds the mother's daughter-in-law and baby granddaughter and ends with her second husband. The mother's brother (not depicted) and second husband (far right) were DNA tested.

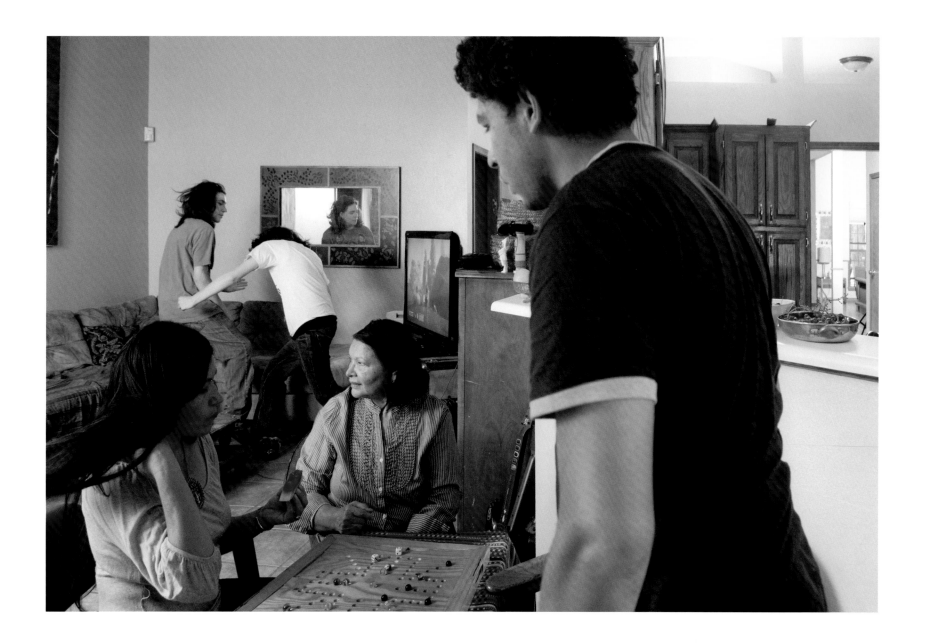

**CASTA 11**
Each of the mother's sons (far left and near right) from her previous marriages was DNA tested for their single-parent extended family casta portrait that includes the maternal grandmother.

ANCESTRAL MIGRATION

MOTHER'S TWIN SON

MATERNAL      - - - - - - - - - - - -

PATERNAL      _____

MOTHER'S ELDEST SON

MATERNAL      - - - - - - - - - - - -

PATERNAL      _____

PERCENTAGE OF REGIONAL ANCESTRY

MOTHER'S TWIN SON

| 30 | 24 | 24 | 15 | 3 | 3 | 2 |
|---|---|---|---|---|---|---|
| NORTHERN EUROPEAN | NATIVE AMERICAN | MEDITERRANEAN | SOUTHWEST ASIAN | NORTHEAST ASIAN | SUB-SAHARAN AFRICAN | SOUTHEAST ASIAN |

MOTHER'S ELDEST SON

| 37 | 19 | 15 | 12 | 7 | 6 | 2 | 2 |
|---|---|---|---|---|---|---|---|
| SUB-SAHARAN AFRICAN | NATIVE AMERICAN | MEDITERRANEAN | NORTHERN EUROPEAN | SOUTHWEST ASIAN | NORTHEAST ASIAN | SOUTH AFRICAN | SOUTHEAST ASIAN |

ANCESTRAL MIGRATION

MOTHER'S BROTHER

MATERNAL          - - - - - - - -

PATERNAL          —————————

FATHER

MATERNAL          - - - - - - - -

PATERNAL          —————————

PERCENTAGE OF REGIONAL ANCESTRY

MOTHER'S BROTHER

| 34 | 29 | 18 | 11 | 5 | 2 |
|----|----|----|----|---|---|
| NATIVE AMERICAN | MEDITERRANEAN | NORTHERN EUROPEAN | SOUTHWEST ASIAN | SUB-SAHARAN AFRICAN | |

NORTHEAST ASIAN

FATHER

| 41 | 39 | 17 | 2 |
|----|----|----|---|
| NORTHERN EUROPEAN | MEDITERRANEAN | SOUTHWEST ASIAN | NORTHEAST ASIAN |

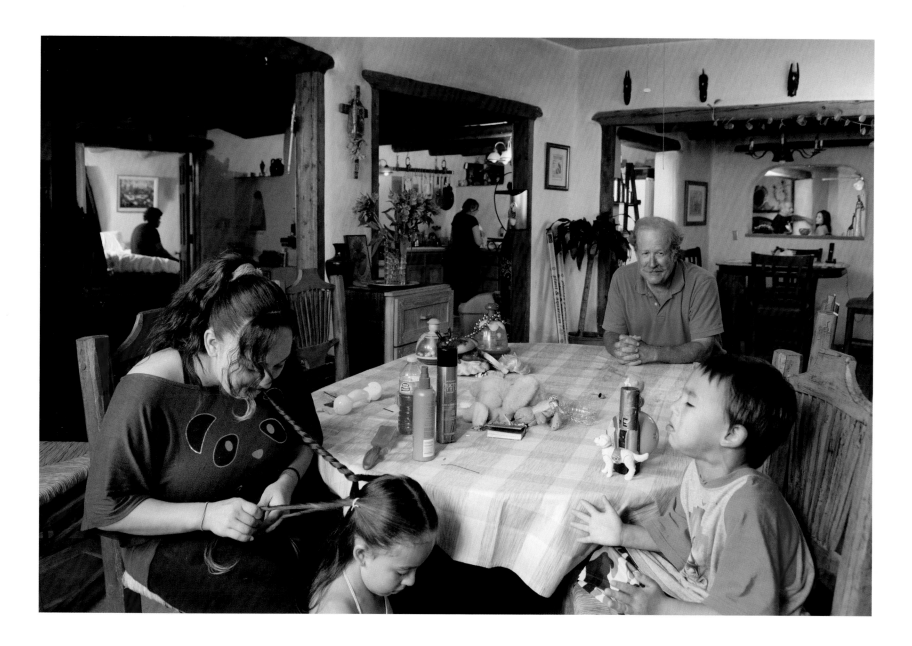

**CASTA 12**

This modern extended family casta portrait foregrounds the mother's granddaughter with her great-grandchildren and her second husband. The mother's brother (not depicted) and second husband (on mother's right) were DNA tested.

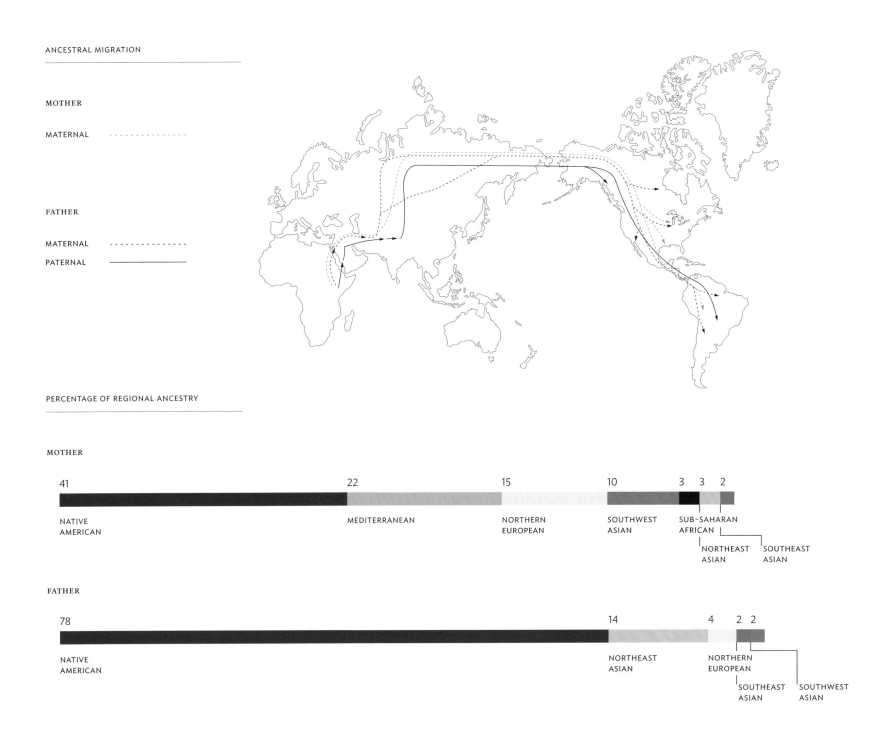

ANCESTRAL MIGRATION

MOTHER

MATERNAL · · · · · · · · · · · · ·

FATHER

MATERNAL – – – – – – –

PATERNAL ———————

PERCENTAGE OF REGIONAL ANCESTRY

MOTHER

| 41 | | 22 | 15 | 10 | 3 | 3 | 2 |

NATIVE
AMERICAN
MEDITERRANEAN
NORTHERN
EUROPEAN
SOUTHWEST
ASIAN
SUB-SAHARAN
AFRICAN

NORTHEAST
ASIAN
SOUTHEAST
ASIAN

FATHER

| 78 | | 14 | 4 | 2 | 2 |

NATIVE
AMERICAN
NORTHEAST
ASIAN
NORTHERN
EUROPEAN

SOUTHEAST
ASIAN
SOUTHWEST
ASIAN

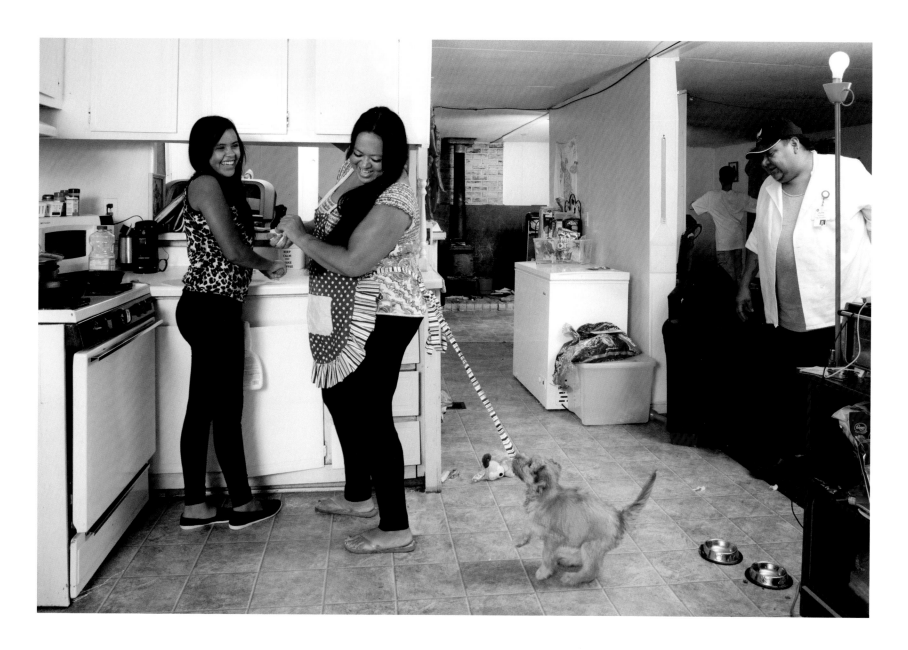

**CASTA 13**

Both parents were DNA tested for their family casta portrait.

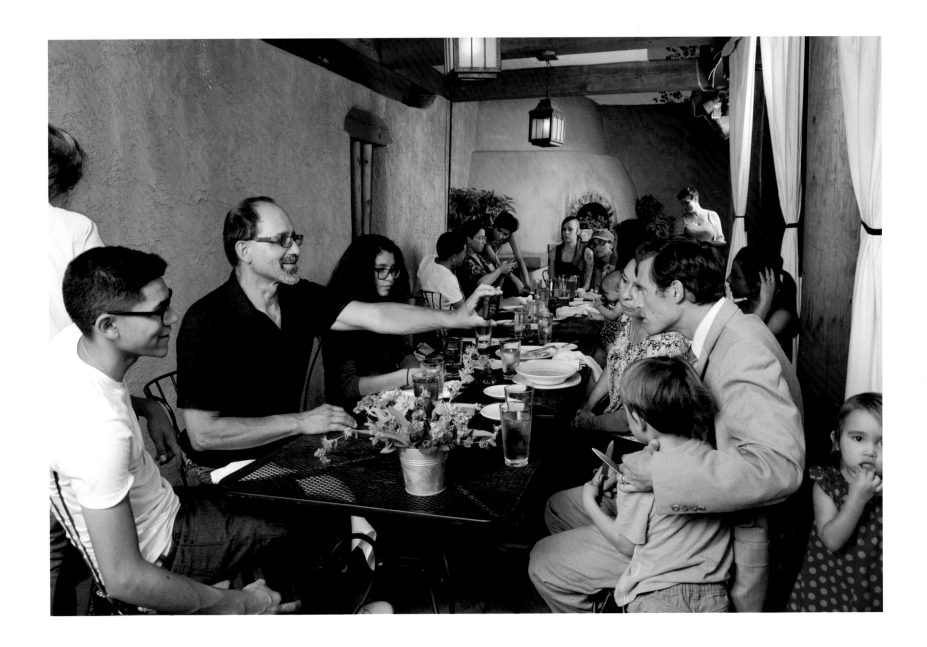

**CASTA 14**

This extended family includes the parent's five daughters with their families. Both the father (left) and the mother's brother (not depicted) were DNA tested for their family casta portrait.

ANCESTRAL MIGRATION

MOTHER'S BROTHER

MATERNAL ---------

PATERNAL ———————

FATHER

MATERNAL --------

PATERNAL ———————

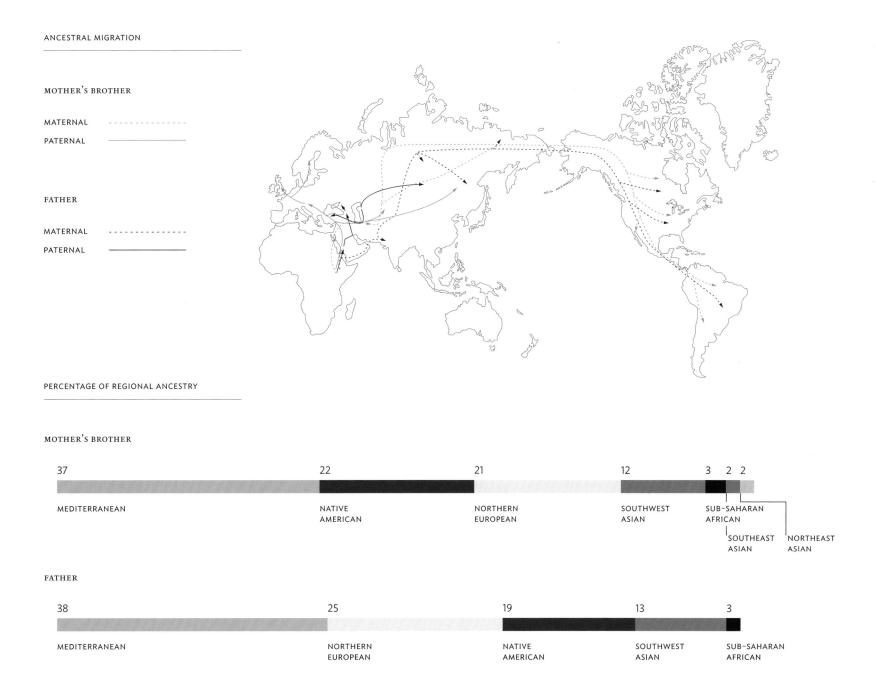

PERCENTAGE OF REGIONAL ANCESTRY

MOTHER'S BROTHER

| 37 | 22 | 21 | 12 | 3 | 2 | 2 |
|---|---|---|---|---|---|---|

MEDITERRANEAN · NATIVE AMERICAN · NORTHERN EUROPEAN · SOUTHWEST ASIAN · SUB-SAHARAN AFRICAN · SOUTHEAST ASIAN · NORTHEAST ASIAN

FATHER

| 38 | 25 | 19 | 13 | 3 |
|---|---|---|---|---|

MEDITERRANEAN · NORTHERN EUROPEAN · NATIVE AMERICAN · SOUTHWEST ASIAN · SUB-SAHARAN AFRICAN

SON

MATERNAL    - - - - - - - - - - - - - -

PATERNAL    ————————————

PERCENTAGE OF REGIONAL ANCESTRY

SON

80                                                                                      10        8        2

SUB-SAHARAN                                                         NORTHERN    MEDITERRANEAN
AFRICAN                                                             EUROPEAN
                                                                                              SOUTH
                                                                                              AFRICAN

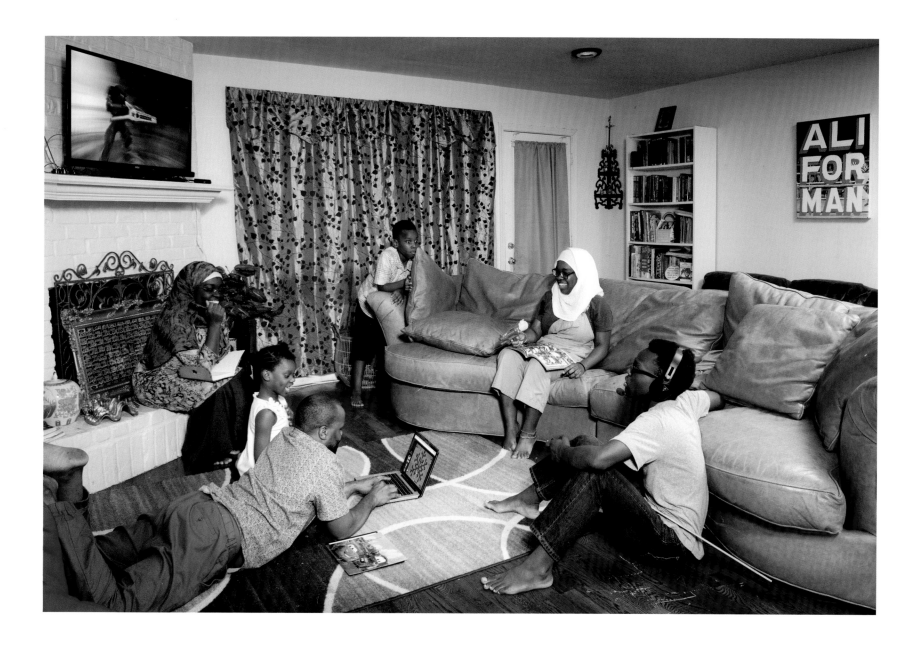

**CASTA 15**

The eldest son (right) was DNA tested for this family's casta portrait.

ANCESTRAL MIGRATION

GRANDDAUGHTER

MATERNAL

PERCENTAGE OF REGIONAL ANCESTRY

GRANDDAUGHTER

| 70 | 19 | 7 | 3 |
|---|---|---|---|
| MEDITERRANEAN | NORTHERN EUROPEAN | SOUTHWEST ASIAN | NATIVE AMERICAN |

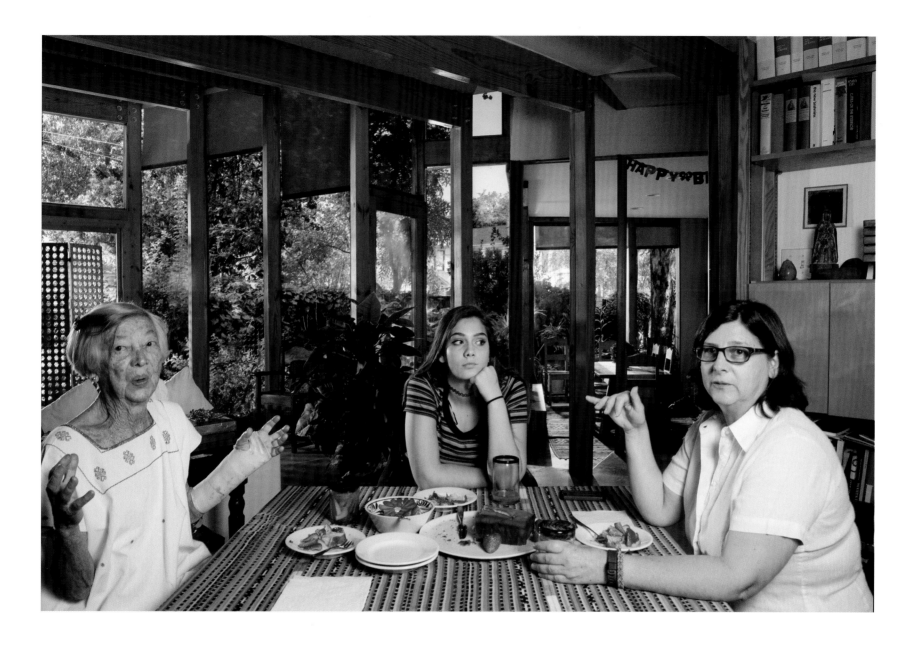

**CASTA 16**

The eldest daughter (center) was DNA tested for their extended family casta portrait.

Holly Barnet-Sanchez

# Delilah Montoya: An Artistic Biography

Delilah Montoya is a Chicana photographer, printmaker and installation artist, working and living in New Mexico and Texas. As an activist artist, she poses herself questions about identity, power, land, borders, gender, community and family that she then explores through her art practice, one that is generally based in series that tell specific stories pointing to larger experiences. Even if she produces a one-off singular work of art, it addresses multiple histories and points of view. One can think of Montoya as an artist/scientist/anthropologist/ sociologist/humanist. Her works are highly cerebral and conceptual on the one hand, and aesthetically dense and psychologically complex on the other. She is an investigator of histories and lives. Her primary subject is the human condition through time and territory as expressed through the lens of being a *mestiza*, a Chicana, someone who claims a hybrid identity and place both in terms of lineage and culture.

As I wrote several years ago, "her artistic home is the cacophony of contemporary Chicano/*a-Mexicano*/*a-Hispano*/a experience in New Mexico."[1] Born in Texas, raised in the Midwest, she has called New Mexico–the ancestral home of her mother's family–home for more than thirty years. Its complex ethno-racial, religious and socio-economic heritage has proved to be a fertile ground for her artistic explorations and collaborations with members of many disparate communities.

Definitions of the term "Chicano" or "Chicana" have varied over time, but the basic ones articulated in the early 1970s still hold: "A Chicano is a Mexican American with a non-Anglo image of himself (Rubén Salazar, journalist)."[2] And, "A Chicano is a politicized Mexican American (Santos Martínez, artist, curator, educator)."[3] Or, "We're still trying to figure that one out," by the comedy troop Culture Clash.[4] Coming from the equally complex identities of being *Hispana* from New Mexico, Delilah adds a further layer of *mestizaje* to her personhood and to the artistic framework within which she works and seeks to make sense of the world.

The Chicano Art Movement, the grounding of her artistic and personal coming of age, began in the mid-1960s in support of the Chicano civil rights movement (*El Movimiento*), an umbrella term for a variety of disparate activist efforts throughout the United States. For the next two decades, using a diversity of media, Chicana and Chicano artists throughout the nation created

artworks that addressed, celebrated and critiqued the rich cultural heritage of the Mexican American people, the political and civil rights struggles of their communities and their commitment to international contemporary cultural and political innovation. If the Chicano Art Movement ended in 1985 or 1990 (as is debated), what has been happening in the past twenty-five plus years? [5] The ongoing artistic experimentation and creative research of Delilah Montoya serve as examples of the continuation and fluorescence of Chicano/a art after the *movimiento* era. Chicana and Chicano art speak to the necessary relationship between art, life and community, and Delilah's continual engagement with various individuals, families and communities as collaborators and full co-creators speaks volumes to the place she has staked out for herself as an artist and fellow community member. Her work is both embedded in her own life and quotidian world, and slightly removed for a sympathetic yet engaged observation that makes her various series possible.

In addition to collaborating on her own series with other artists or members of her communities, she is a founding member of an artists' and activists' collective based in Texas but incorporating people from Mexico as well: Sin Huellas (Without a Trace). This phrase refers to the practice of erasing one's fingerprints to avoid detection by authorities as one attempts to evade deportation. Based in the notion of bringing to fuller attention the actual practices of ICE (Immigration and Customs Enforcement) and the frequent tragedies surrounding the daily realities of families held in detention, Sin Huellas produces installations to "trace the silhouettes we cannot see, listen to the conversations that we cannot record, and peer into the scenes that would rip our souls if we were forced to experience them."[6] Delilah's earlier 2004–2008 panoramic photographic series "*Sed*-Trail of Thirst," marking the deadly absence of water in the border region and concerned citizens' efforts to make it available, ties in with this group's efforts.

Her most notable works of the past twenty-some years include several individual and series projects: "Codex Delilah, Six Deer, Journey from Mexicatl to Chicana" (1992), "El Sagrado Corazón" (1993), "From the West, Shooting the Tourist" (1995), "El Guadalupano" (1999), "Sebastiana" (2001), "La Llorona in Lillith's Garden" (2004), "Women Boxers: The New Warriors"

(2006) and her most recent and ambitious effort, "Contemporary Casta Portraiture: Nuestra 'Calidad.'" While each of these projects are unique unto themselves, addressing various questions and challenges in terms of theme, content, form, technology and aesthetics, they resonate with each other in a number of important aspects. Montoya ties deep tradition to innovation, multiple histories to the present, transformation as a liminal space—a *nepantla* space—to what came before and what will be going forward.[7] Most all of her work is grounded in the ideas of hybridity, of the journey of being and becoming tied to deliberate and continual transgression of what is expected or even demanded. Her artist's statements are substantive meditations on the findings of her research, a study of her intellectual/artistic processes that lead to the final work(s) of art. As a result, the reader/viewer is, in effect, invited to become a part of the ongoing lives of her series. A comparison between "The Sacred Heart" collotype series and "Contemporary Casta Portraiture" makes it possible to pull some of these threads together for observation and contemplation.

Both are collaborative projects bringing together individuals and families who sit for their portraits within a specific context and who are invited to participate in creating—at least in part—the environment of that portrait. Both series have an overarching theme that speaks to the past and the present. In the case of "The Sacred Heart," Delilah focused on one of the most startling symbols of Catholicism, bringing to the fore the hybrid/syncretic nature of its existence in the Americas and beyond—the union of Aztec and early Christian symbolism—in the depiction of the Sacred Heart of Jesus: the embodiment of life itself, of faith, love, charity and sacrifice in an essential human organ that was venerated differently by both forms of religious practice. In *Contemporary Casta Portraiture*, she "mimics" (her own word) the efforts to document and make sense of miscegenation in the New World, specifically the ill-fated system in New Spain to understand and control "purity" and status among the population of the Spanish colonies.

"The Sacred Heart" series exists in a lush, layered and enclosed environment, created in her graduate studio, the walls, floors and ceiling covered in a palimpsest layering of graffiti art by her daughter's high school artist friends.

Every scene takes place there; so there is a visual continuity between the portraits of author Rudolfo Anaya, flamenco *maestra* Eva Encinias Sandoval, Delilah's auto-mechanic working on a carburetor (what he sees as the heart of the automobile) and a group of wonderful young girls and boys becoming young women and men in front of our eyes. Props, items selected from the lives of each sitter that represent his or her sense of the Sacred Heart, are included in each composition. The contexts or environments we see in the casta portraits do not have that obvious immersion in one locale. But the overwhelming quotidian quality of each location provides that connection. The genre painting quality of the castas paintings of the eighteenth and early nineteenth centuries are beautifully transformed into a contemporary genre environment using staged photography.

The earlier project was immersed in faith and belief–the external visualization of the internal, the objectification of the ineffable. The second project is based in Enlightenment efforts at classification and "scientific" understanding of race, ethnicity, power, status and control. Delilah's castas takes control away from an external central authority (whether Church or State) and makes it available to the sitters, the co-creators, to define themselves within the contexts of who they are on a daily basis and who they are in terms of their genetic inheritance. How in fact does that genetic inheritance make itself visible, if at all? (In the works of art, it is made visible beneath each photograph through the use of colored sand. But do we see it in the photographs themselves?) And do the enormous varieties of mixing point in fact to the reality that none of us are so very different from each other? In both series, we are dealing with surface difference and the deep, abiding resonance of being of "the same stuff."

Each of the sitters in "El Sagrado Corazón" were personally invited to work with Delilah, were known to her prior to the project and had some kind of real relationship to the Sacred Heart. For "Contemporary Casta Portraiture," she sent out a variety of calls for people interested in learning about their own DNA and who would be willing to work with her to create the environment that best expressed the aspects of their lives they wanted to foreground or share. In each case, participants, co-creators, were given enormous agency to define themselves conceptually, aesthetically, and in terms of their beliefs and being-ness. What happens as a result in each series is a bit of magic, a bit of alchemy, a bit of collective exploration and self-revelation to which we, the viewer, are invited in to share.

1   Holly Barnet-Sanchez, "Delilah Montoya," *Encyclopedia of Latinos and Latinas in the United States* (NY: Oxford University Press).

2   Rubén Salazar, "Who Is a Chicano? And What Is it the Chicanos Want?" *Los Angeles Times*. 6 February 1970. One can date these definitions to an early moment in the *movimiento* by the focus on men only.

3   Chicano: "...–a Mexican-American involved in a socio-political struggle to create a relevant, contemporary and revolutionary consciousness as a means of accelerating social change and actualizing an autonomous cultural reality among other Americans of Mexican descent. To call oneself a Chicano was a blatantly political act ...," according to Santos Martínez in *Dále Gas– Chicano Art of Texas* (Houston: Contemporary Arts Museum, 1977).

4   Richard Montoya, Ricardo Salinas, Herbert Sigüenza, "Glossary of Terms," *Culture Clash: Life, Death and Revolutionary Comedy* (New York: Theatre Communications Group: 1998), p. xxii.

5   Holly Barnet-Sanchez's Syllabus for "Chicana and Chicano Art: A History of an American Art Movement, 1965 to the Present," an upper division and graduate level course taught in the Department of Art and Art History at the University of New Mexico between 1996 and 2013 with frequent revisions. See "Teaching Chicana/o and Latina/o Art in Practice, Six Syllabi," *Aztlán: A journal of Chicano Studies* 40:1 (Spring 2015), p. 211.

6   *Sin Huellas*, unpublished manifesto, undated.

7   Gloria Anzaldúa, "Border arte: Nepantla, el lugar de la frontera," in *La Frontera-The Border: Art about the Mexico-Unites States Border Experience* (San Diego, CA: Centro Cultural de la Raza & The Museum of Contemporary Art, San Diego, 1993), pp. 107–114.

# Exhibition History

2014     "Sinful Saints and Saintly Sinners," curator Patrick Polk, Fowler Museum at UCLA, Los Angeles.

"Painting the Divine," curator Josef Díaz, New Mexico Museum of History, Santa Fe.

"Work from the Permanent Collection," Lissa Cramer, Tuffs University Art Gallery, Medford. MA.

2013     "Autophotography," Axle Contemporary, Santa Fe.

"Group Show," Photos Do Not Bend, Dallas.

2012     "Domestic Disobedience: Female Artists Redefine the Feminine Space,"curated by Nuvia Crisol Ruland, San Diego Mesa College Art Gallery, San Diego.

"The Fine Folk of New Mexico: People, Places and Culture Through Art," Santa Fe Community Gallery, Santa Fe.

2011     "Case Studies from the Bureau of Contemporary Art: Selections from the New Mexico Museum of Art Contemporary Collection," curator Laura Addison, Santa Fe.

"Her Gaze/ Su Mirada," curator Maruca Salazar, Museo de las Américas, Denver.

"Arte Tejano: De Campos, Barrios y Fronteras," OSDE Espacio de Arte, Buenos Aires, Argentina.

"En Foco/In Focus: Selected Works from the Permanent Collection," Light Work's Robert B. Menschel Photography Gallery, Schine Student Center, Syracuse University, Syracuse.

"Splendors of Faith/Scars of Conquest," Oakland Museum, Oakland.

2010     "Embracing Ambiquity: Faces of the Future," Cal State Fullerton Main Art Gallery, Orange County, California.

"Albuquerque Now: Winter," Albuquerque Museum of Art & History, Albuquerque.

"Shrew'd: The Smart & Sassy Survey of American Women Artists," Sheldon Memorial Art Gallery, Lincoln.

"El Grito," Brad Cushman, UALR Gallery, Little Rock.

2009     "Chicana Badgirls: Las Hociconas," co-curator Delilah Montoya, 516 ARTS, Albuquerque.

"$timuls: Artadia Awardees 2008 Houston," DiverseWorks, Houston.

"New Prints 2009/Summer Prints: In Pursuit of Likeness", IPCNY, New York City.

"Chicana Art and Experience: AFL-CIO," Washington, DC.

"Status Report: An Exhibition about the Border, Immigration, and Work," BRIC Contemporary Art, Brooklyn.

2008     "Death + Memory in Contemporary Art," The Landmark Arts Gallery (Texas Tech University), Lubbock.

"Photography: New Mexico," University of New Mexico Art Museum, Albuquerque.

"Screened Expressions: A Series Print Project Retrospective," Mexican American Cultural Center, Austin.

"New Prints 2008/Spring–Selected by Jane Hammond," New York School of Interior, New York City.

"A Declaration of Immigration," National Museum of Mexican Art, Chicago.

"Serie Quinceañera," Mexi-Arte Museum, Austin.

2007     "Aquí No Hay Vírgenes: Queer Latina Visibility," The Village, Los Angeles.

"Lifting the Veil: New Mexico Women and the Tricultural Myth," Institute of American Indian Arts Museum. Santa Fe.

"Common Threads," Robert Hughes Gallery, San Antonio.

"Lost & Found 2: Missing in Plain Sight," curated by Kathryn Davis, Patina Gallery, Santa Fe.

"Mirada de Mujer," Photos Do Not Bend, Dallas.

2006   "Contemporary Art Houston," Shanghai Art Museum, Shanghai, China

"Caras Vemos, Corazones No Sabemos: The Human Landscape of Mexican Migration to the United States," The Snite Museum of Art, University of Notre Dame, Notre Dame.

2005   "La Madre Poderosa," The Harwood Museum of Art, Taos.

"Los Nueve - The Nine, Fine Art Exhibition," Hispanic Heritage Conference, Corpus Christi.

"Ojo Caliente,"Joe Díaz Collection, National Hispanic Cultural Center Museum, Albuquerque.

2004   "Common Ground: Discovering Community in 150 Years of Art," Corcoran Museum of Art, Washington, DC.

"Atravesando Fronteras: Lines that Unite\Lines that Divide," El Museo Cultural de Santa Fe.

"La Familia: Returning to Aztlán '04," The dA Center for the Arts, Pomona.

"Art, Culture, Place: Visual Traditions of the Southwest," University of New Mexico Art Museum, Albuquerque.

"Contested Narratives: Chicana Art from the Permanent Collection," The Mexican Museum, San Francisco.

2003   "El Corazón," Millicent Rogers Museum, Taos.

"Altered States: Digital Art," Gallery at University of Texas-Arlington, Arlington.

"¡PicARTE! Photography Beyond Representation," Heard Museum, Phoenix.

2002   "Ahora: New Mexican Hispanic Art," Art Museum of the National Hispanic Culture Center, Albuquerque.

"El Espejo, Arte Latino from Texas," ArtScan Gallery, Houston.

"Arte y Cultura," Carnegie Art Museum, Port Hueneme.

"Who's the Virgin of Guadalupe?" Henry Street Settlement, Abrons Art Center, New York City.

2001   "Tufts University Collections Selection," Aidekman Arts Center, Medford.

"Lifting the Veil," Karen Stambaugh Gallery, Miami.

"Discontent," College of Santa Fe Art Gallery, Santa Fe.

"La Luz: Contemporary Latino Art in the US," Art Museum of the National Hispanic Culture Center, Albuquerque.

2000   "Arte X Diex," New Mexico State Capitol Building, Santa Fe.

"Nuevo Me-Xicanos: Contemporary Chicano Art of New Mexico," curator Delilah Montoya, Magnifico Gallery, Albuquerque.

"Revealing and Concealing: Portraits and Identity," Skirball Cultural Center, Los Angeles.

1999    "The End of the Trail: Photographic Fin-De-Siècle, Part I and II," Andrew Smith Gallery, Santa Fe.

"Recent Acquisitions," Museum of New Mexico, Museum of Fine Arts, Santa Fe.

1998    "Ida y Vuelta: Twelve New Mexico Artists," Musée Denys Puech, Rodez, France

1997    "Talk Back: The Community Response to the Permanent Collection," Bronx Museum,
New York City.

"American Voices, Latino Photographers in the US," Smithsonian International Gallery, Washington, DC.

1996    "History as Influence: American Work from New Mexico," Soros Center for Contemporary Art, Kiev, Ukraine.

"Chambers of Enchantment," CEPA Gallery, Buffalo.

"Day of the Dead 1996," Mexican Fine Arts Center Museum, Chicago.

"Intersecting Identities," University of Southern California Fisher Gallery, Los Angeles.

"Refiguring Nature: Women in the Landscape," SF Camerawork, San Francisco.

1995    "From the West," curator Chon Noriega, The Mexican Museum, San Francisco.

1994    "Guadalajara International Book Fair," Guadalajara, Mexico.

"American Voices, Latino/Hispanic/Chicano Photography in the US," Fotofest, Houston.

"America's Cultural Diversity: CAJE '94," Center of Creative Arts, University City, Missouri.

1993    "The Friends of Photography Auction 1993," Ansel Adams Center, San Francisco.

"Chicanolandia," curator Roberto Buitrón, M.A.R.S., Phoenix.

**SELECTED TRAVELING EXHIBITIONS**

2013–2016    "Our America: The Latino Presence in American Art," Smithsonian American Art Museum, curator
Carmen Ramos.

2013–2017    "Estamos Aquí (We Are Here)," Exhibits USA, curator Brad Cushman.

2011–2013    "Infinite Mirror: Images of American Identity," Airtrain, curator Blake Bradford, co-curators Benito
Huerta, Robert Lee.

2008–2010    "Phantom Sightings: Art after the Chicano Movement," LA County Museum, co-curators Rita Gonzalez,
Howard Fox, and Chon Noriega.

2003    "Only Skin Deep: Changing Visions of the American Self," International Center for Photography,
co-curators Coco Fusco and Brian Wallis.

2000–2003    "Arte Latino: Treasures from the Smithsonian American Art Museum," Smithsonian American
Art Museum.

1999–2000    "Imágenes e Historias: Chicana Altar-inspired Art," Tufts University Art Gallery, curator Constance
Cortez.

| 1990–1993 | "Chicano Art: Resistance and Affirmation, 1965–1985," Wight Art Gallery, University of California at Los Angeles, co-curators Judith F Baca, Holly Barnet-Sanchez, Marcos Sanchez-Tranquilino, Edith Tonelli and Rene Yáñez. |
| 1992–1994 | "The Chicano Codices: Encountering Art of the Américas," The Mexican Museum, San Francisco, curator Marcos Sanchez-Tranquilino. |

**SELECTED COLLECTIONS**

Los Angeles County Museum of Art

Museum of Fine Arts Houston

Mexican Museum, San Francisco

The Bronx Museum, New York City

Smithsonian Institute

Wight Art Gallery, University of California at Los Angeles

Stanford University Libraries

Armand Hammer Museum, Los Angeles

Museum of Fine Arts, Santa Fe

Tufts University Collections, Aidekman Arts Center

Julia J. Norrell Collection, Washington, DC

Joe Díaz Collection

National Hispanic Cultural Center Art Museum, Albuquerque

Gil Cárdenas Collection, Notre Dame, Indiana

**SELECTED PUBLICATIONS**

**Books**

*Women Boxers: The New Warriors.* Houston: Arte Público Press, 2006.

*Rearing Mustang/ Razing Mesteño. Born of Resistance: Cara a Cara Encounters with Chicana/o Visual Culture.* Eds. Victor A. Sorrel and Scott L. Baugh. Tucson: University of Arizona Press, 2015.

**Articles by the Artist**

"Mirror, Mirror: the Latino/a as the 'Other' in the Fine Arts." College Arts Association Abstracts (2005): 44.

"On Photographic Digital Imaging." Aztlán: A Journal of Chicano Studies (2002): 181.

"Using a Cultural Icon to Explore a People's Heart." Nieman Reports 55 (2001): 19.

**SELECTED CATALOGS**

*Voices in Concert: In the Spirit of Sor Juana Inés de la Cruz*. Eds. Mark Cervenka and Grace Zúñiga. Houston:
    Arte Publico Press, 2015.

*Visualizing Albuquerque: Art of Central New Mexico*. Ed. Joseph Traugott. Albuquerque: Albuquerque Museum, 2015.

*Our America: Latino Presence in American Art*. Washington, DC: DGiles Limited Press, 2014.

*Painting the Divine: Images of Mary in the New World*, Ed. Josef Díaz. Albuquerque: Fresco Books, 2014.

*Encounters: Photographs from the Sheldon Museum of Art*. Lincoln: University of Nebraska Press, 2013.

*Arte Tejano de Campos, Barrios y Fronteras*. Ed. Moreno Cesário. Buenos Aires: Fundación OSDE, 2011.

*Photography New Mexico*. Thomas F. Barrow and Kristin Barendsen. Santa Fe: Fresco Fine Art, 2008.

*Phantom Sightings: Art after the Chicano Movement*. Eds. Rita González and Chon Noriega. Los Angeles: LA County
    Museum, 2007.

*Caras Vemos, Corazones no Sabemos / Faces Seen, Hearts Unknown*. Eds. Amelia Malagamba and Gilberto Cárdenas.
    Notre Dame, IN: University of Notre Dame, 2006.

*Common Ground: Discovering Community in 150 Years of Art*. Washington, DC: Corcoran Gallery of Art, 2004.

*Only Skin Deep: Changing Visions of the American Self*. Ed. Fusco Y. Wallis. NY: ICP & Abrams, 2003.

*Arte Latino: Treasures from the Smithsonian American Art Museum*. Ed. Jonathan Yorba. NY: Watson-Guptill
    Publications, 2001.

*Revealing & Concealing: Portraits & Identity*. LA: Skirball Cultural Center, 2000.

*Imágenes e Historias: Chicana Altar-Inspired Art*. Ed. Constance Cortez. Medford, MA: Tufts University, 1999.

*Ida y Vuelta*. Ed. Laurence Imbernon. Rodez, France: Musée des Beaux-Arts Denys-Puech, 1998.

*From the West*. Ed. Chon Noriega. San Francisco: Mexican Museum, 1996.

*The Fifth International Festival of Catalogues Photography*. Ed. Liz Branch. Houston: FotoFest Inc., 1994.

*Chicanolandia*. Ed. Robert Buitrón. Phoenix: MARS Art Space, 1993.

*Chicano Art: Resistance and Affirmation*. Eds. Richard Griswold del Castillo, Teresa McKenna, and Yvonne Yarbro Bejarano.
    LA: University of Southern California-Los Angeles, Wight Art Gallery, 1990.

*Contemporary Art by Women of Color*. Curator/essayist Lucy Lippard. San Antonio: Guadalupe Cultural Arts
    Center, 1990.

**GALLERIES**

Andrew Smith Gallery, Fine American Photography. Santa Fe, New Mexico. (505) 984–1234.
<http://www.andrewsmithgallery.com>
Photographs Do Not Bend. Denton, Texas. (214) 969–1852.
<http://pdnbgallery.com/SITE/>

# Contributors

Surpik Angelini is an artist, independent curator and director of the Transart Foundation for Art and Anthropology in Houston, Texas.

Mia Lopez is an assistant curator at the De Paul University Art Museum. She was a curatorial fellow for visual arts at the Walker Art Center in Minneapolis.

Delilah Montoya is a professor of photography and digital media at the College of the Arts, University of Houston. She has been included in numerous national and international exhibitions, including *Chicano Art Resistance and Affirmation* and *Phantom Sightings: Art after the Chicano Movement*.

Holly Barnet-Sanchez is an associate professor emerita of art history at the University of New Mexico. She is the coeditor of *Signs from the Heart: California Chicano Murals* and a contributor to *Mexican Muralism: A Critical History*.